E. E. O'Donnell SJ

Foreword by Dr Robert D. Ballard

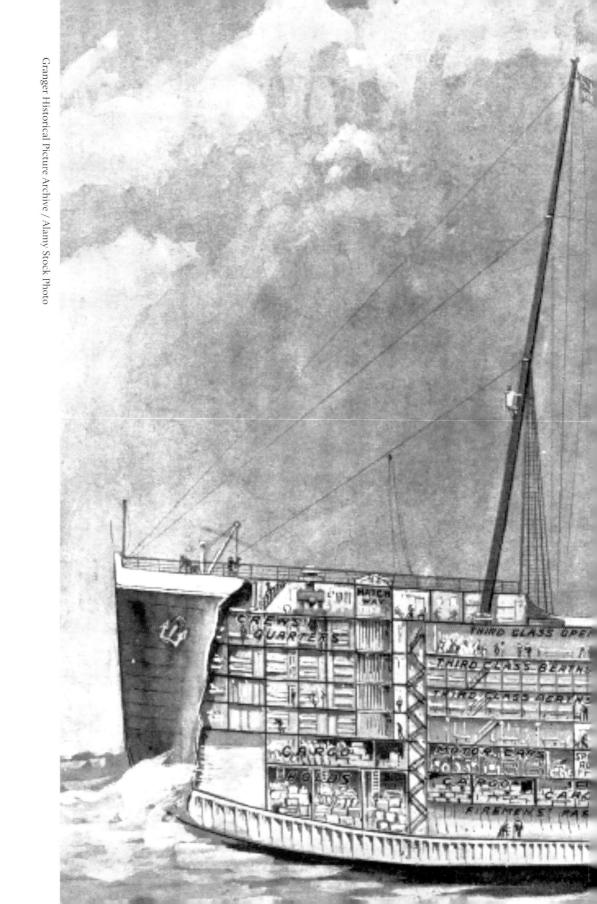

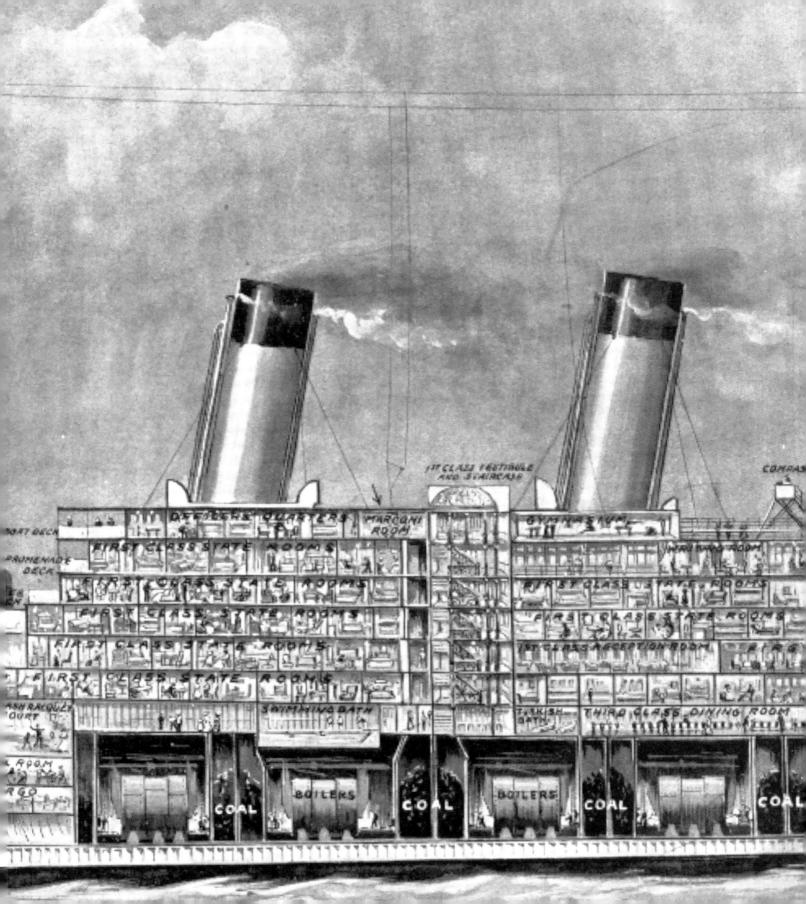

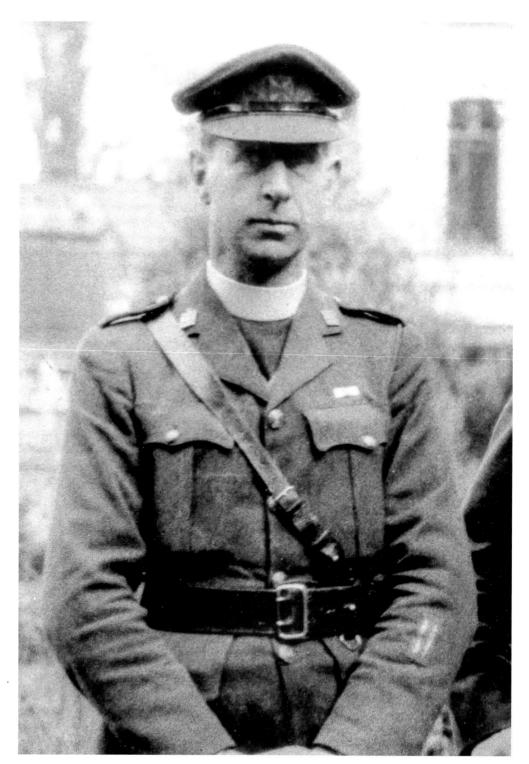

Fr Frank Browne SJ, MC. Chaplain to Irish Guards, 1915–1920.

DEDICATION

To those who died that night

Text Copyright © 2011, E. E. O'Donnell SJ

The right of E. E. O'Donnell SJ to be identified as the author of the Work has been asserted by him in accordance with the Copyright and Related Rights Act, 2000.

Photographs copyright © The Father Browne SJ Collection

Father Browne SJ prints are available from
Davison and Associates,
A5 Network Enterprise Park
Kilcoole
Co. Wicklow A63AE68
Ireland
www.fatherbrowne.com

The material in this publication is protected by copyright law. Except as may be permitted by law, no part of the material may be reproduced (including by storage in a retrieval system) or transmitted in any form or by any means, adapted, rented or lent without the written permission of the copyright owners. Applications for permissions should be addressed to the publisher.

First Edition published by Wolfhound Press, Dublin, 1997
Centenary Edition published by Messenger Publications, 2011
Third Edition, Messenger Publications, 2016
Fourth edition, Messenger Publications, 2022
Fifth Edition, Messenger Publications, 2024

ISBN 9781788126854

Designed by Messenger Publications Cover design by Brendan McCarthy Photograph colorising: Edwin Davison Typeset in Kepler Std & Candara Printed by GPS Colour Graphics

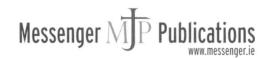

Messenger Publications, 37 Leeson Place, Dublin D02 E5V0 Ireland www.messenger.ie

Contents

Acknowledgements
Foreword by Dr Robert D. Ballard11
Introduction
Chronology16
Chapter 1: The White Star Line at Queenstown18
Chapter 2: Father Browne's <i>Titanic</i> Photograph Album32
Chapter 3: Journey to the <i>Titanic</i>
Chapter 4: The <i>Titanic</i> Photographs in Detail56
Chapter 5: The <i>Titanic</i> Photographs in Context
Chapter 6: Sailing aboard the <i>Titanic</i>
Chapter 7: The <i>Titanic</i> arrives at Queenstown
Chapter 8: The <i>Titanic</i> Sinks
Chapter 9: Browne's <i>Titanic</i> Photographs in the Public Imagination128
Chapter 10: Grieving the <i>Titanic</i>
Letter from the <i>Titanic</i> Historical Society140
Index141

Acknowledgements

My sincerest thanks to those who have helped me put this book together. Fr John Guinev SI, former Treasurer of the Irish Jesuits (who kept the Browne album safe for many years); Karen Kamuda of Ludlow, Mass. (who masterminded my profitable journey to New England early in 1997); her husband the late Ed Kamuda (who not only wrote the preface but showed me around his *Titanic* Museum at Indian Orchard, Mass, and gave me many fascinating souvenirs); Dr Robert D. Ballard of Woods Hole, Cape Cod (who kindly invited me to his home and agreed to write the foreword); the Editor of The Belvederian (for permission to reproduce the article in chapter six); Andrea and Eddie Doherty of Long Island (for their hospitality in New York and for showing me White Star relics there); Mr Tom McCluskie, Administration Manager of Harland and Wolff Ltd (for inviting me to the liner's birthplace in Belfast); Mr Donald Hyslop of the Maritime Museum, Southampton (for showing me the *Titanic* memorabilia there); Melvin Lash and Jasper Coffman of the Marine Museum, Fall River, Mass. (for showing me their 30-foot model of the *Titanic* and many other treasures related to the liner); Donald Lynch and Ken Marschall of Redondo Beach, California (for invaluable help with the captions); Stephen Brooks, Military History Officer, Portsmouth City Museum; Lt Cdr Liam Smith of Cobh (who formerly worked for James Scott & Co, the shipping agents who sent Frank Browne his Titanic ticket); David Aherne, the eighty-seven-year-old former Pilot of Cobh (who is blessed with a brilliant memory and gave me its full benefit); Vincent McMahon, Manager of Irish Ferries, Cork (who went to a lot of trouble in producing documents invaluable to my research); Maura Kennedy of the Gilbert Library, Dublin (for letting me read the Dublin newspapers of April 1912); Edwin Davison of Dublin (for computerising Frank Browne's captions and finding the relevant ones for this book, and for digitalised prints); his father, David Davison, previously Head of the Photographic Department, Dublin Institute of Technology (for making the prints, and for his digitalised prints, as well as his enlargement of the final photograph of Captain Edward Smith); Ursula and Ted O'Brien (who did such a fine job in presenting my material); Seamus Cashman of Wolfhound Press, the original publisher; Fr Donal Neary, Cecilia West and Paula Nolan of Messenger Publications; Senan Molony (author of The Irish Aboard 'Titanic') for drawing my attention to Father Browne's piece in the *Cork Constitution* which is reproduced here in full. Finally a special word of thanks to Titanic historian Vincent McMahon - already acknowledged above – for many further services rendered since the original publication of this book.

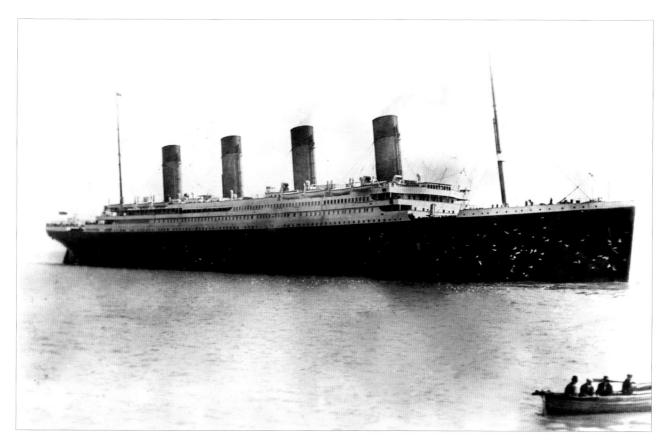

One of Frank Browne's last photographs of *Titanic*, taken at Queenstown (Cobh) on 11 April 1912. He sent this picture to the Odell family and it is sometimes erroneously attributed to them. The twelve photographs taken by the Odells, who disembarked with Frank Browne at Queenstown, are the only other surviving pictures of *Titanic* taken by maiden voyagers.

Dr Robert D. Ballard, head of the deep submergence laboratory, Woods Hole Oceanographic Institution, points to a drawing of the sunken luxury liner, *Titanic*, pointing out the missing smoke stack and other portions of the deck photographed by the institution's deep-towed sonar and video camera system, Argo. Photograph taken during a press briefing at the National Geographic Society on 11 September 1985.

© Keystone Press / Alamy

I felt privileged when Fr Eddie O'Donnell SJ came to visit me at my home on Cape Cod in January 1997. In a certain sense, I felt he was a kindred spirit as I was aware that he had made a major discovery in 1985, when he found Father Browne's collection of more than 42,000 photographs. I knew that ten books of these pictures had already been published, including one in French. The purpose of his visit was also clear, and I was delighted to oblige him by agreeing to write this foreword.

Some of Browne's *Titanic* photographs were already familiar to me since I had used many of them in my own books (such as *The Discovery of the Titanic*) but I had not seen the album in its entirety, nor had I read Browne's account of the maiden voyage as far as Queenstown.

Looking through these photographs taken decades ago, I recalled very vividly my first glimpses of the liner on the sea floor in 1985. The one of the lifeboat hanging in its now empty davits and the one of the anchor being raised for the last time were poignant reminders of what we found two-and-a-half miles beneath the surface of the Atlantic Ocean

Let me single out one picture in particular. During my second visit to the liner in 1986, as our underwater robot, *Jason Junior*, slowly passed by the gymnasium windows, remnants of the gym equipment could be seen, including some of the metal grillwork that had protected such contraptions as the electric camel – a turn-of-the-century exercise machine. Browne's photograph of the interior of that gymnasium (p. 71) and the card given to him by Mr McCawley – the ship's physical education officer – bring home to me in a really tangible way the fact that human beings once exercised their muscles there. The single word 'lost' in Browne's caption reinforces my belief in the sacredness of the gravesite.

Apart from the photographs I was fascinated – as I am sure every reader will be – by Browne's description of his days on board; and I was intrigued by the poem he wrote afterwards.

The additional materials that have been included make this a most unusual book; so it is with great pleasure that I commend Fr O'Donnell's work and wish the book the success it deserves.

Foreword

Introduction

Frank Browne was born in Cork on 3 January 1880. He was the eighth child of Brigid and James Browne. On 8 January he was baptised in the Cathedral Church of St Mary and St Anne in Shandon, which stands beside the famous steeple of that name. The next day his mother died of puerperal fever. James too was to meet a tragic end: he drowned while swimming in the ocean when Frank was in his teens.

Brigid Browne was a niece of James Hegarty, Mayor of Cork, and a cousin of Sir Daniel Hegarty, who became Cork's first Lord Mayor. Like her husband, a wealthy merchant, she had grown up in the leafy and prosperous Cork suburb of Sunday's Well, where she had been prominent in the social and charitable life of the parish. With the passing of his mother and father, it was Robert Browne, his uncle, the Bishop of Cloyne, who was to be Browne's guide and father-figure.

Frank Browne's schooldays were spent at the Bower Convent in Athlone, Christian Brothers College in Cork, Belvedere College in Dublin and Castleknock College in County Dublin. He graduated from Castleknock in 1897 and then set out on a tour of mainland Europe with his brother and a new camera. The camera was a gift from his uncle, Robert. The photographs he took with this gift in France, Italy and Switzerland marked the beginning of a photographic life that is still being celebrated today, more than a century later.

This camera was not Robert's only gift to Frank Browne. In 1912 Robert gave him a second gift – almost as life-defining as the first – a two-day cruise on the world's largest liner, the ill-fated RMS *Titanic*, as it journeyed to Queenstown, modern-day Cobh. Invited to stay on board for the remainder of the voyage, the tragedy of the *Titanic* almost claimed Frank Browne's life. He might have been another victim of the sea, like his father. Only the intervention of his superior – the Jesuit provincial – stopped him from continuing with the *Titanic* on its journey across the Atlantic.

Initial reports indicated that while the *Titanic* had sunk, all passengers had been saved. It was not until several days after the sinking that the truth was known. Frank Browne's photographs became an essential part of the reportage of the tragic story of the *Titanic*. They gave people all over the world a visual connection to the victims – over 1500 of them.

Yet, a complete set of Frank Browne's *Titanic* photographs did not appear until the publication of this book. Not only this, but the full extent of his rich photographic life was not made public until the late 1980s. When Browne died in 1960 his negatives were deposited in the archive of the Irish Jesuits. In 1985, more than twenty years later, I was rummaging around in the archive when I spotted an old trunk, buried beneath layers of files and documents. Chalked on the lid of the trunk were the words 'Father Browne's Photographs'. At the time, the inscription meant little to me. I vaguely remembered that a priest called Browne had been on the maiden voyage of the *Titanic* and that his photographs had been used in newspapers at the time of the tragedy. What I didn't know was the full extent of the treasure I had just discovered: tens of thousands of negatives, all neatly captioned and dated.

When this book of Browne's *Titanic* photographs was originally published it became an immediate bestseller on both sides of the Atlantic. It was translated into French, Hungarian and Japanese. An exhibition, sponsored by the Sony Corporation, was shown in six Japanese cities. James Cameron incorporated some of Browne's photographs into his epic film *Titanic*. In particular, Cameron's 'Children's Playground' scene is based on Browne's photograph (p. 74), right down to the way in which the actors are dressed. The photographs have now appeared in over fifty exhibitions across the world, travelling – without incident – from an old trunk in the Jesuit archive to Tokyo and Tacoma, Sydney and San Diego, Boston and Berlin, and everywhere in between.

The majority of the photos I found in the Jesuit archive were taken after 1912. They tell, in part, the story of Frank Browne's life: Chaplain to the Irish Guards during the First World War, Superior of St Francis Xavier's Church in Dublin, travels to South Africa, Australia, Sri Lanka and many other places; Vice-President of the first Irish International Salon of Photography, contributor to *The Kodak Magazine* and recipient of a lifetime's supply of free Kodak film. Today, Frank Browne is celebrated primarily as a master photographer. It is no longer the case that the most newsworthy fact about him is that he sailed on the *Titanic*. Nonetheless, these photographs of the *Titanic* and its passengers continue to hold a special fascination for people all over the world.

national biological property of the second s

Introduction

THE ILL-FATED TITANIC.

A crowded audience at the Victoria Theatre, Galway, last night, listened with undivided attention to the story of 'The Ship Phat Never Returned,' as unfolded in a lantern lecture by Very Rev. F. M. Browne, S.J. The lecture was held under the auspices of the men's sodality attached to St. Ignatius Col-lege, and dealt with the subject of shipbuilding from wood and sails to the modern leviathans, with their palatial appointments and invery. By far the most interesting section of it was that which told of the story of the Titanic, the largest ship affoat, which went to her doom amidst the ice-floes of the Northern Atlantic Father Browns is obviously a most enthusiastic photographer, and le sailed on the Titanic on her first and last trip, but was fortunate enough to dis-embark at Colsh. His sides of the start-ing trip, the cheering crowds, the pre-monitory accident in the Solent, the wondrous luxury, the arrival at Cobh, and the departure into the Atlantic from which she never returned, thrilled his audience. Then came the last sad S.O.S. addence. Then called the last sail S.O.S. telegrams sent out to the bitter end by the brave wireless operator. Earlier in the lecture we were shown the earliest ships that sailed the sens, including the bout of the great discoverer or the New World, and the evolution from wood and sails to steam was clearly and interestingly illustrated. The magazinume interestingly illustrated the programme was well arranged by father Stephenson, the spiritual director of the sedality, and the following contributed to the concert: the following confrience De the concert: Lev. R. W. Gabbaghov, S.J.; Miss A. Fahy, Mrs. Wallier, Miss Queenie Costello, Mr. P. Bernerick, Mr. P. Herran, Chr. H. Binke, Messrs, T. Beatty and P. McCann, Dr. David, Dr. S. Shea, Messrs, N. O'Hallosen and F. Lenhan.

Frank Browne and the Sea

From early on his life Frank Browne was linked to the sea. His uncle Robert was Bishop of Cloyne. The bishop's residence stood beneath the Cathedral of St Colman in what was then Queenstown (today, Cobh). It was Bishop Browne who added to the cathedral its tall spire, which for many Irish people was their last glimpse of home as they departed for new lives in places like the USA. For Browne, Queenstown was a place he felt at home. He spent many summers there as a child and continued to visit throughout his life.

Queenstown was a bustling transatlantic port. Besides being a hub for passengers and trade, it was also a major base of the Royal Navy. It was so significant that a British naval presence remained there, by treaty, until 1938, a full sixteen years after Ireland had gained independence.

In his youth, Browne was a familiar figure on the quayside. His connection to Bishop Browne allowed him entry to areas that were inaccessible to the general public. He was friendly with the masters of two Queenstown tenders, *America* and *Ireland* (p. 29). They brought him out to the liners and let him photograph them. He also knew the master of the tug *Flying Sportsman*. He came to know a great deal about how the port functioned.

The wider Browne Collection contains photographs of ships from many different countries. From the era of sailing ships there are pictures of the *Atacama* (Denmark), *Archibald Russell* (Great Britain), *C B Peterson* (Australia) and *Mercator* (Belgium) to mention but four. From the steam age we have the American Line's *Haverford* and *Philadelphia*, the German ship *Hertzogin Cecilie*, the Inman Line's *City of Paris* and the Anchor Line's *Californian*. Royal Navy vessels include the HMS *Inflexible* and the Admiralty Yacht *Enchantress* with Mr Winston Churchill on board.

When transatlantic liners became bigger and faster in the early decades of the twentieth century, the greatest rivalry emerged between the White Star Line and Cunard. Vying for a greater share of the market, the former lured passengers by stressing the luxury of their appointments, the latter by the speed of their ships. Browne points out this distinction in his captions.

Browne photographed Cunard's *Caledonia, Franconia, Laconia, Lusitania* and *Mauretania* and White Star's *Arabic, Adriatic, Baltic, Celtic, Megantic, Oceanic* and of course *Titanic* and her sister ship *Olympic*.

The Frank Browne Collection Exhibited and in Print

The first selection of Frank Browne's photographs was published by Wolfhound Press in 1987. It became a bestseller in Ireland. Many experts took an immediate interest in the photographs and came to view the collection. The first of these, David Davison (Head of the Department of Photography at what was then Dublin's Institute of Technology), explained that it would be essential to transfer the negatives from their nitrate base to safety-film before the images disintegrated. Thanks to sponsorship by Allied Irish Bank (AIB) and the work of David Davison and his son Edwin Davison, the negatives were transferred and the images saved.

Annual exhibits of Browne's work began in 1992. In 1993 the Guinness Brewery mounted a large exhibition of the Dublin pictures in its Hopstore Gallery. In 1994 RTÉ (Ireland's national television service) aired six half-hour documentaries on the collection. In 1995 and 1996 Australian and French editions of Browne's work were published. The French edition coincided with an exhibition of Browne's photographs at the Georges Pompidou Centre in Paris, where presidents Jacques Chirac and Mary Robinson were in attendance. Since the 1990s Browne's photographs have been exhibited all over the world

Frank Browne's work is still regularly exhibited and discussed today. In 2014, the documentary *Fr Browne's Forgotten War* aired. In the same year E. E. O'Donnell SJ published *The Life and Lens of Father Browne* and *Father Browne's First World War* (both Messenger Publications). In 2015 an exhibition entitled 'Frank Browne: A Life through the Lens', curated by David and Edwin Davison, was mounted in Dublin and Belfast. In the same year Yale University Press published a review of Browne's work. In 2020 a collection of Browne's photographs of Wicklow with a commentary by Robert O'Byrne, *Wandering Wicklow with Father Browne*, was published. Messenger Publications continues to publish collections of his photography.

E. E. O'Donnell SJ holds a Doctorate in Communication from the University of Southern California. He has been associated with the work of Frank Browne ever since his 1985 discovery of the 42,000 neatly dated and captioned negatives in a much-travelled trunk. As curator of the collection he has overseen the publication of many books of Frank Browne's photographs. In 2014 he published *The Life and Lens of Father Browne* (Messenger Publications).

Leading to the continues of

Chronology

1908 White Star Line signs contract with Harland & Wolff,

Belfast shipbuilders, for three new liners, *Olympic*,

Titanic and Gigantic.

Construction of Olympic begins.

1909 Construction of *Titanic* begins.

1910 Olympic launched.

Titanic launched.

Maiden voyage of Olympic.

1912 Construction of Gigantic begins (her name will be

changed to *Britannic* after the April tragedy).

March Fitting out of *Titanic* completed. Modifications and

improvements willmake her heavier than Olympic,

and thus the largest ship afloat.

Specifications:

Length: 882 feet 9 inches.

Breadth: 94 feet.

Height: 180 feet (including funnels, which rise 84

feet above the Boat Deck). Engines: 46,000 horsepower.

Capacity: 46,328 tons.

Displacement: 52,250 tons.

2 April Sea trials in the Irish Sea. *Titanic* reaches a speed of 20

knots (although capable of 24 knots).

3 April Titanic reaches Southampton where provisioning and

staffing begin.

10 April Frank Browne travels by train from London to

Southampton.

Maiden voyage of *Titanic* begins under Captain Edward Smith, formerly Captain of *Olympic*.

Titanic reaches Cherbourg, France at 6.30pm.

II April Voyage from Cherbourg to Queenstown (Cobh),

Ireland, where Frank Browne disembarks.

Titanic sails for New York at 1.55pm.

14 April *Titanic* collides with iceberg at 11.40pm.

Stated position (see p. 137) 41° 46' N, 50° 14' W.

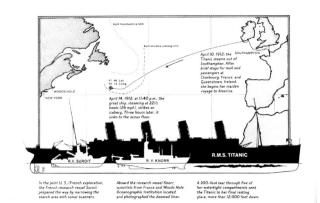

Actual position (13.5 miles away) 41° 44' N, 49° 57' W.

Conditions: 'Flat Calm'.
Sky: Cloudless; moonless.

Temperature: 31°F (-1°C).

15 April 12.25am. Passengers told to take to the lifeboats,

'women and children first'.

Board of Trade Lifeboat Requirement: 962 spaces (for a maximum total of 3,511 passengers and crew). *Titanic's* Lifeboat Capacity (16 lifeboats, plus four collapsible boats): 1,178 spaces (for an approximate total of 2,225 passengers and crew at the time).

2.20am Titanic sinks.

4.10am *Carpathia* reaches scene of the tragedy. *Carpathia* reaches New York with 705 survivors, the only ones to be saved; and Frank Browne's

Approx. 1,520 passengers and crew perish.

photographs appear in newspapers.

19 April US Senate Investigation into *Titanic* disaster begins. It will end on 25 May. Its report will call for the setting up of a commission to investigate all laws and regulations regarding construction and

equipment of ocean-going vessels.

2 May

British Board of Trade Investigation into *Titanic*disaster begins. Its recommendations, issued on
3 July, will call for the better provision of
lifeboats and for better watertight compartments

lifeboats and for better watertight compartments.

Wreck of *Titanic* found at depth of 12,460 feet on a joint French American expedition.

a joint French-American expedition led by Dr Robert D. Ballard of Woods Hole Oceanographic Institute, Massachusetts, USA. The position of *Titanic's* wreckage proved that the liner was not nearly as far west as Captain Smith believed. More importantly it showed that Captain Lord's liner *Californian* was many miles away. It was the lights of the still unidentified 'mystery ship' that the passengers of the *Titanic* had seen in the middle distance.

Chronology

Hearses lined up on Halifax wharf to carry RMS *Titanic* victims to funeral parlours, Halifax, Nova Scotia, Canada, 6 May 1912

1985

18 April

Chapter 1

The White Star Line at Queenstown

How the harbour prepared for sailings

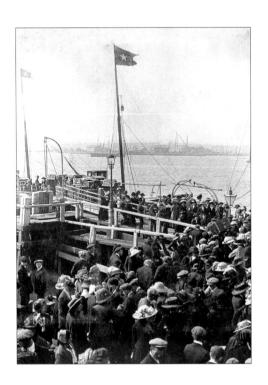

Before a liner could leave Queenstown for the USA a lot of things had to be done: preparing cargo and passenger manifests, filling in documents for customs clearance, unloading mailbags off a train bringing post from the United Kingdom, checking departing passengers through the emigration authorities, among many other things.

As a final hurdle passengers were interviewed by a United States consul. Those intending to remain in the USA had to have their eyes examined for trachoma by an American doctor (p. 28).

Queenstown bustled with life on the day of a sailing. Porters jostled for jobs; White Star officials attended to the special needs of infants and the infirm; vendors and hawkers plied what Frank Browne called 'Legal and Illegal Trade' (p. 22); American ladies bought their last samples of Irish lace (p. 21). All of this was accompanied by the sound of the local pipe band, and when the tenders were leaving the liner, having delivered passengers, cargo and mail, a lone trumpeter played a final salute.

When Frank Browne was leaving Waterloo Station in London on the morning of 10 April 1912, he would have known that frantic preparations were already under way in Queenstown. While the *Titanic* made its way from Southampton to Cherbourg and on to Queenstown, ships from Liverpool and New York would arrive at the port. It was the imminent arrival, however, of the largest liner in the world that would cause the most excitement.

Passengers disembarking at White Star Wharf, Queenstown.

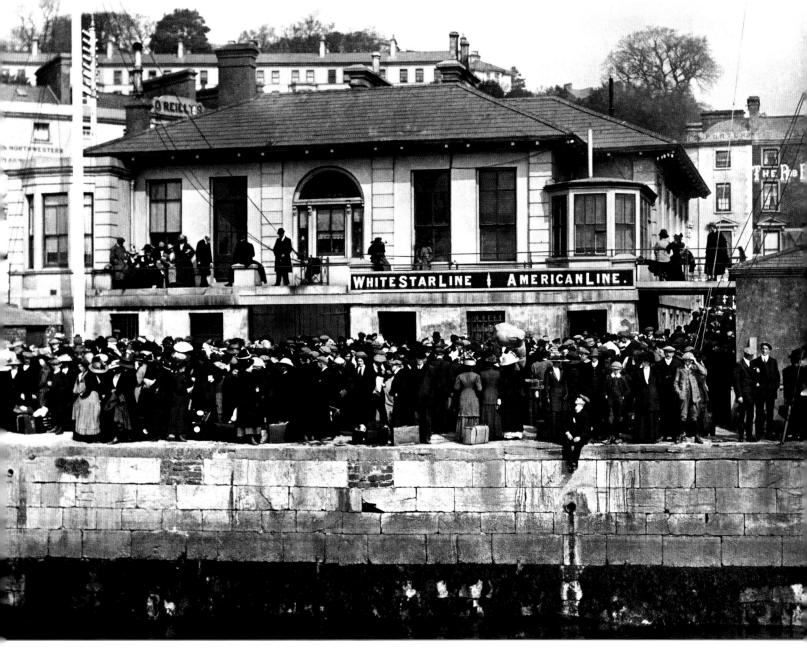

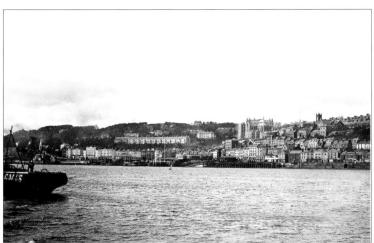

Above: Crowds waiting to embark on the tenders at White Star Wharf, Queenstown.

Left: A view of Queenstown from the tender before the spire was added to St Colman's Cathedral by Browne's uncle, Bishop Robert Browne of Cloyne.

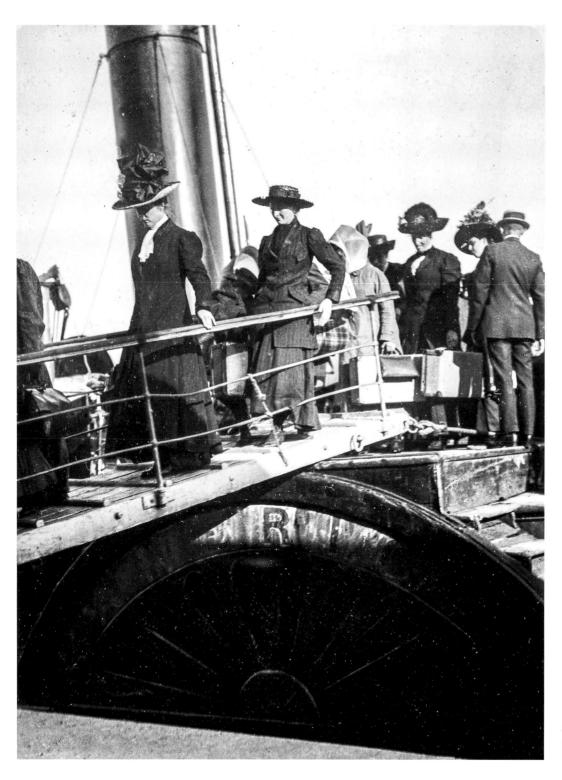

American ladies disembarking from the tender *America*.

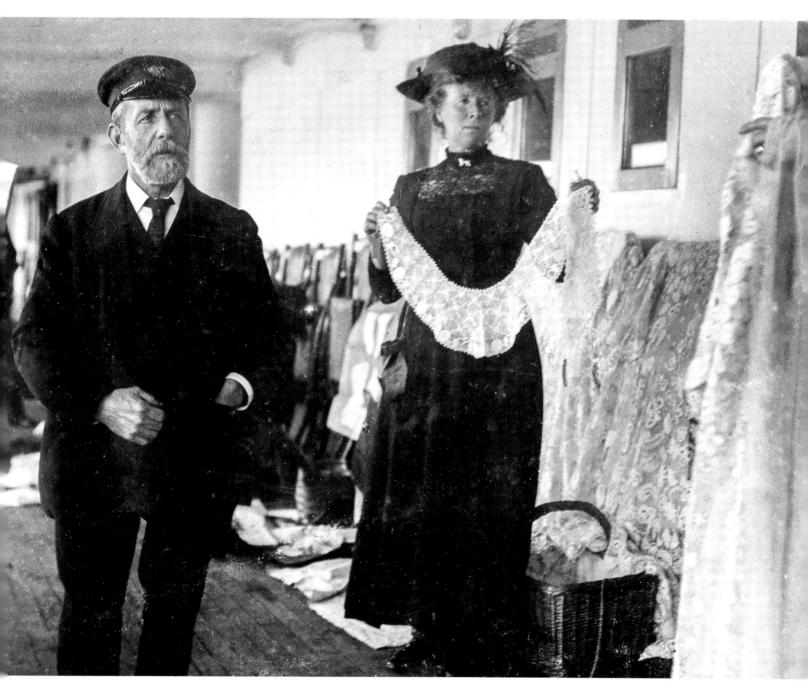

Queenstown vendors had franchises to sell Irish lace and other souvenirs aboard the transatlantic liners.

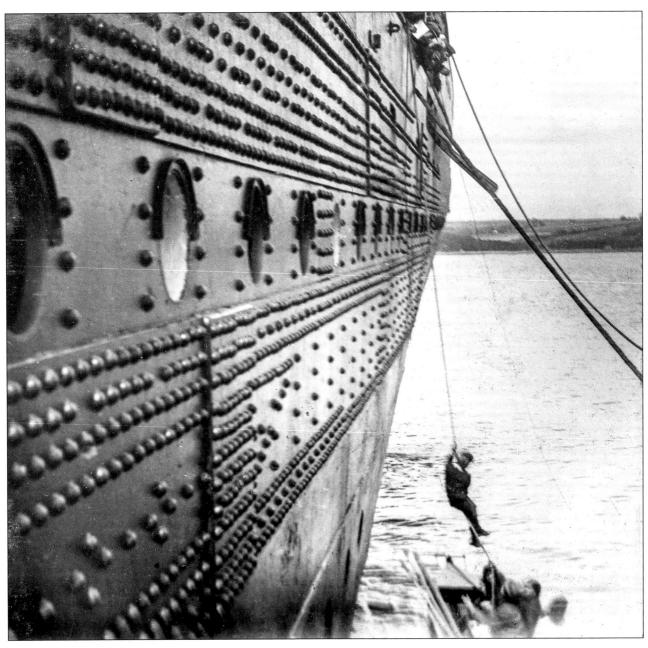

Illegal trade in progress alongside a liner.

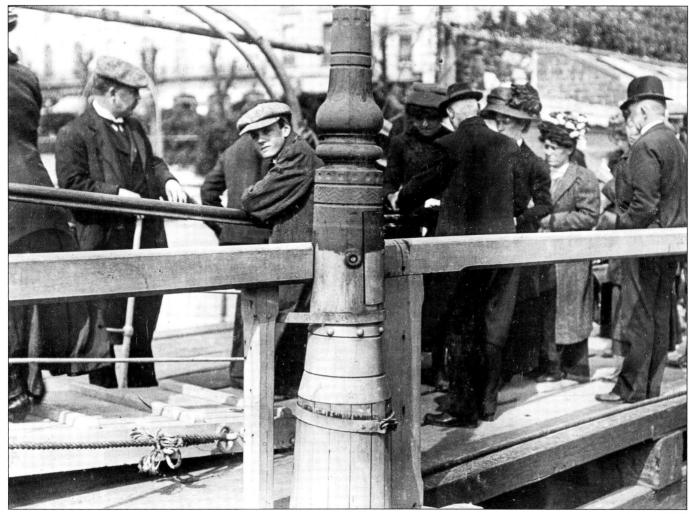

Porters waiting for employment to transfer mails.

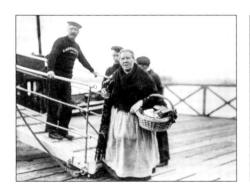

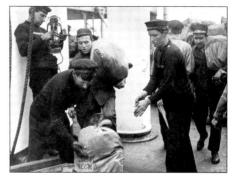

Right to left: Authorised trader, Mrs Galvin, on the Queenstown wharf awaiting the arrival of passengers. 'A drop in the mail!' Hopefully, nothing fragile is in the bags being dropped into the hold. Crewmen loading mail and adjusting a liner's lantern.

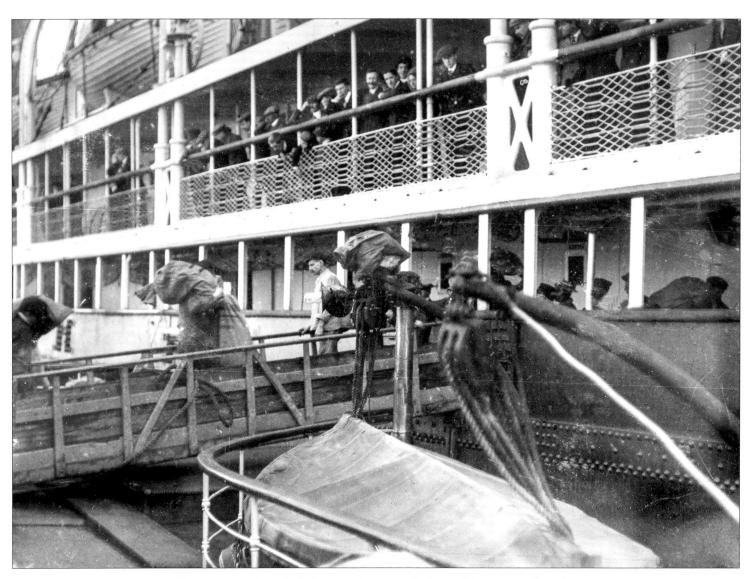

Passengers on board a White Star liner watch the mail being transferred.

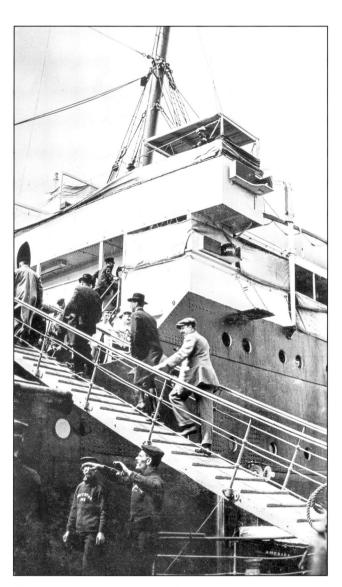

First-class passengers mount the gangway.

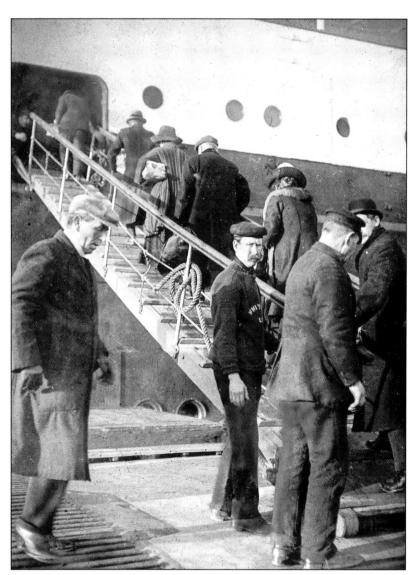

Second-class passengers embarking from the tender Ireland.

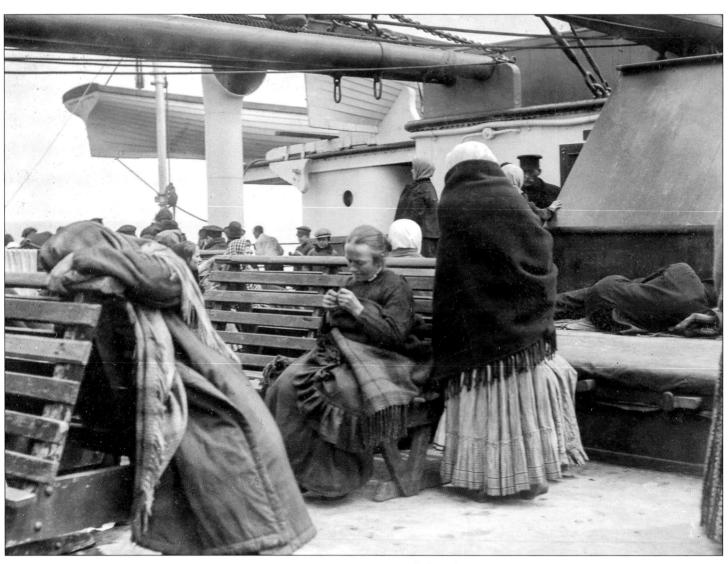

Steerage passengers getting settled on deck.

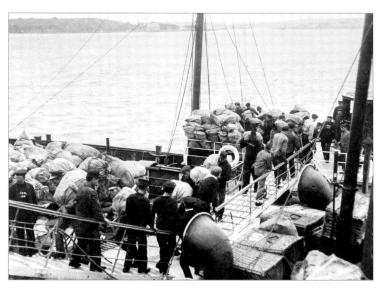

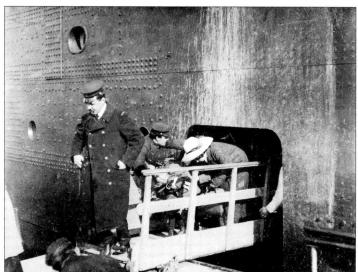

Clockwise from top left: Loading the mails which had come by rail on the 'American Mail Special' from Cork. Mother and child receive special attention. Mail-bags and trunks ready for loading after passengers have boarded.

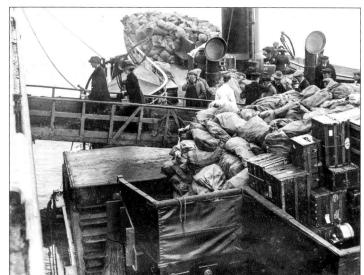

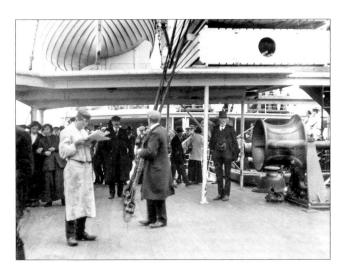

Porter 'spotting form' on the steerage deck. Note the 'English Style' rafts beside the lifeboat at the top of the picture.

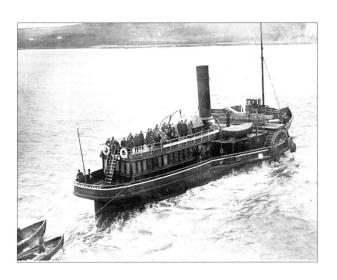

The tender *Ireland* departing from a liner with a small number of passengers.

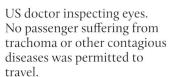

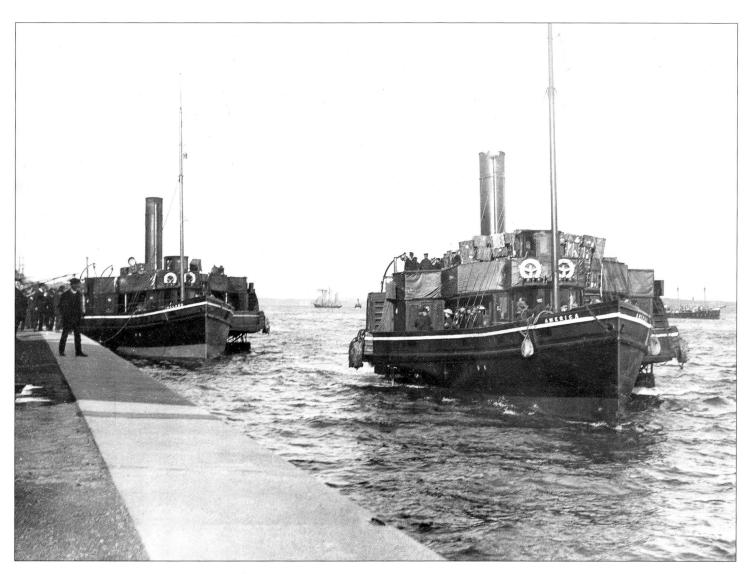

The tenders *Ireland* and *America* off Deepwater Quay.

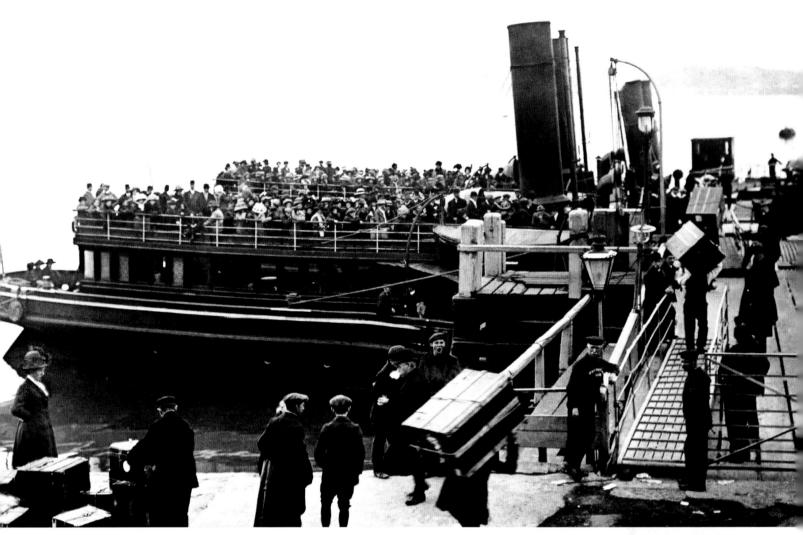

A final few trunks being added to the already crowded tenders.

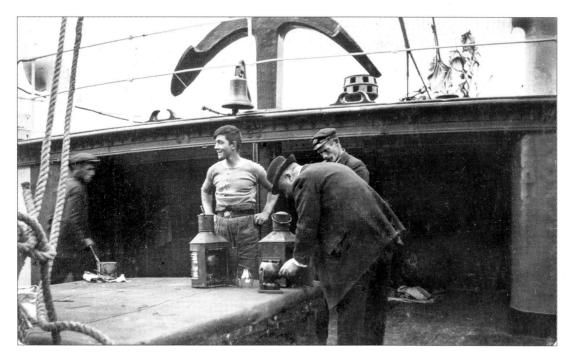

The signal lamps being inspected by a Port of Cork official. Normally this task was carried out by one of the liner's officers.

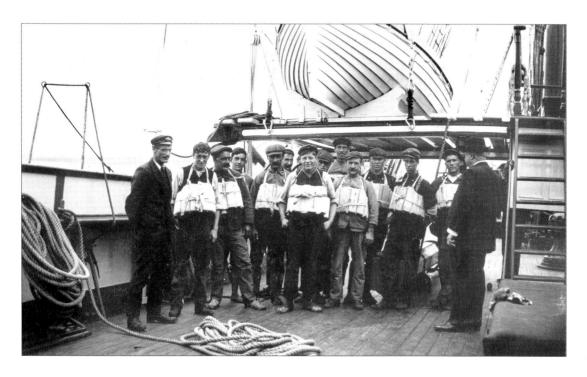

One of the formalities of the port involved lifeboat drill and the inspection of lifejackets.

Chapter 2

Father Browne's *Titanic* Photograph Album

Browne completed his *Titanic* album in the year 1920. Altogether, the album comprises 63 pages with a total of 159 photographs. It also contains press cuttings and other printed memorabilia.

Originally, Browne pasted his photographs on separate sheets of cream-coloured mount-board and added his captions in handwriting. Then he gave these sheets to a book-binder who trimmed the pages before binding them together in a heavy leather cover. Unfortunately, some of the captions were cut off during this trimming process. In most cases, however, the missing words are easy to 'fill in'.

It should be noted that the album, unlike the rest of the Browne Collection, was never 'lost'. While the trunkful of 42,000 negatives lay buried in the Jesuit archive in Dublin, the album was kept in a safe by Fr John Guiney SJ, treasurer of the Jesuit Order in Ireland. He knew that the album was a valuable asset, although even he was surprised when a London newspaper, after taking professional advice, valued the album at two million pounds sterling. Apart from the album itself, however, the rest of the material that appears in this book *was* in the now famous trunk and temporarily 'lost'.

The pages that follow show most of the leaves of the album that relate to the *Titanic*, including the ones taken at Waterloo Station in London prior to the departure of the train for Southampton. In chapter four, these photographs will be enlarged and commented on in more detail.

This Album - with original photos taken by him is the property of Rev. Francis. M. Browne. S.J.

To whom, please, it is to be returned.

Dublin.

December 28th 1920.

Belvedere College.

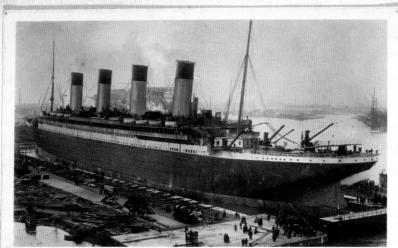

The first Unclouded Hours

Photo by

This Card was purchased from the Jounge Skwart on board the Titavie.

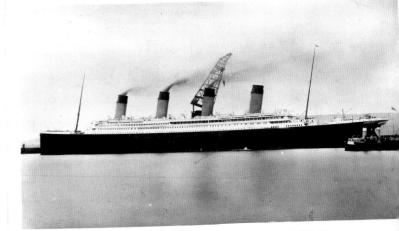

WHITE STAR LINER R. M. S. "TITANIC" LAUNCHED 31 ST MAY 1911, SUNK OFF CAPE RACE ON MAIDEN VOYAGE, 15 TH APRIL 1912, 1565 PASSENGERS LOST.

(Signal Series of Post cards)

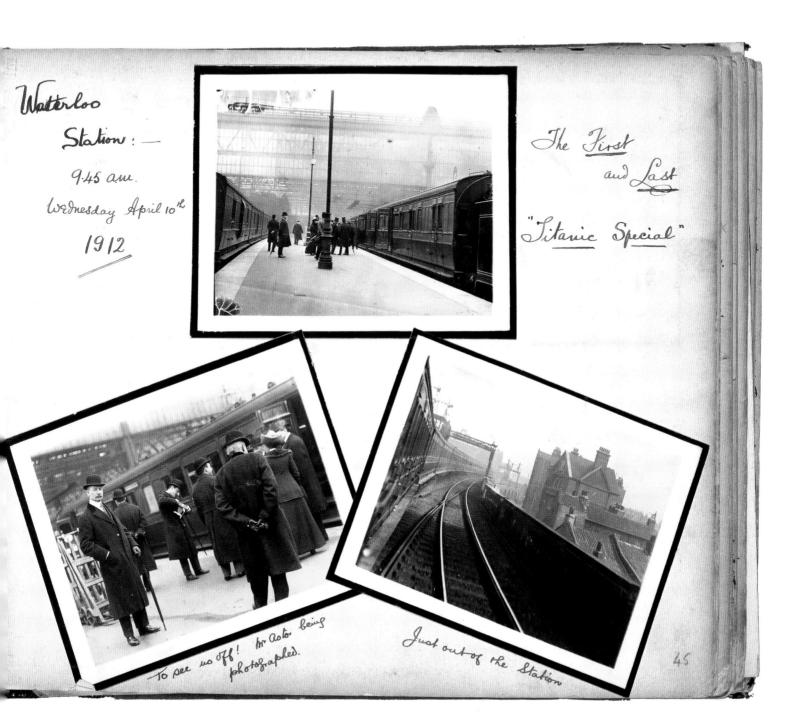

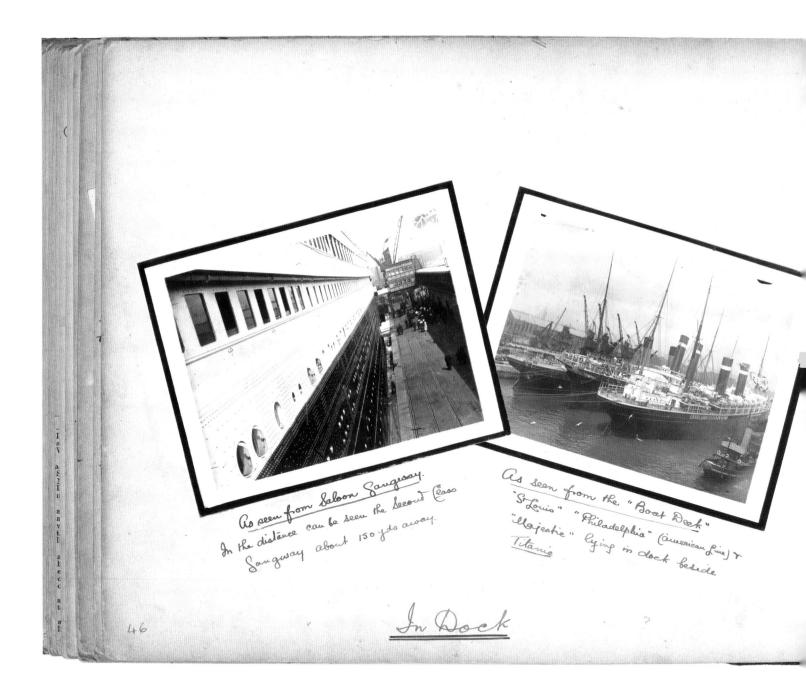

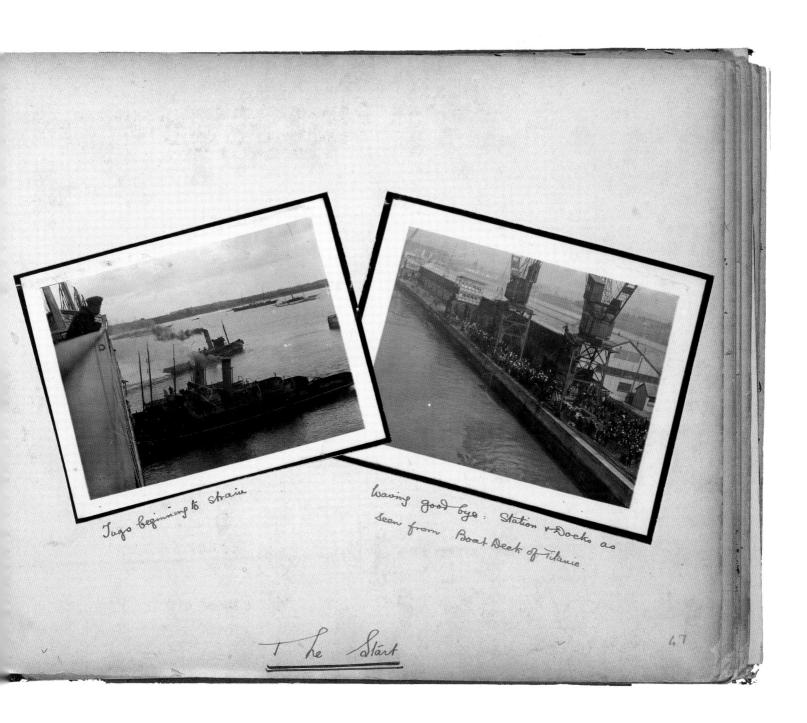

Scarce four hundred yards down the fetties were.
"moond two other great livers, the "Oceanie" of
"the "New York". The "New York" being on the
"outside was thronged with sightness pages to cheer
the great this, on her maiden trip. be on the
"Titania" erowded the sides to return their salutes.

Suddenly there was a crack followed by a structede
of the sightness on the "New York", then four more cracks
like pistol shots in quick succession, the great 10,000 fon
liver, her stall cables having shorapped like thread,

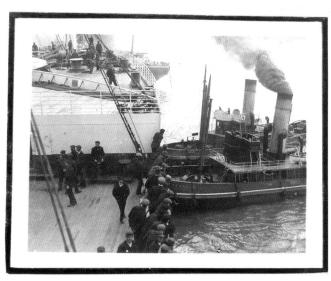

drifted from her mootings, drawn into the fairway by the wash of the Titanic".

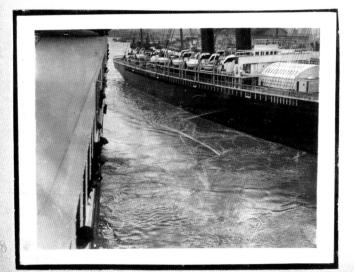

The "Vew york"

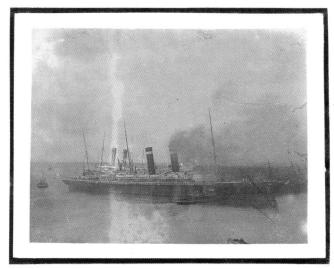

ceased, but on came the helpless "New York." Tup blews their syrens, & moked toher aid but on she came. A voice beside me said "Now for a crash," + I snapped myshuffer. Then we mushed aft along the death to see what would happen, but only to see the black huse of the "New York" glide cently past out into the open space where a few seconds before had been the stern of the "Titanie"

Soon the Tugs drew in the broken cables, and the "New York" was lowed slowly past us. Even then however, she was not out of the way, for when the "Titanic" reversed her engines, to give a little most room, once most the "New York" was drawn across our bows. It was but for a moment, of the we slowly forged a head down Southampton water, with the Channel open rfree beforens: (I soon Beliederian 1912)

Bello clanged from the Bridge of the "Titanie" of daraway aft the chutning of the propellers

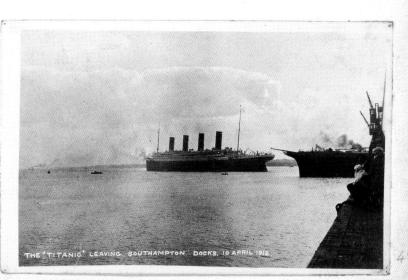

Incident

J.g. arnott, Photo.

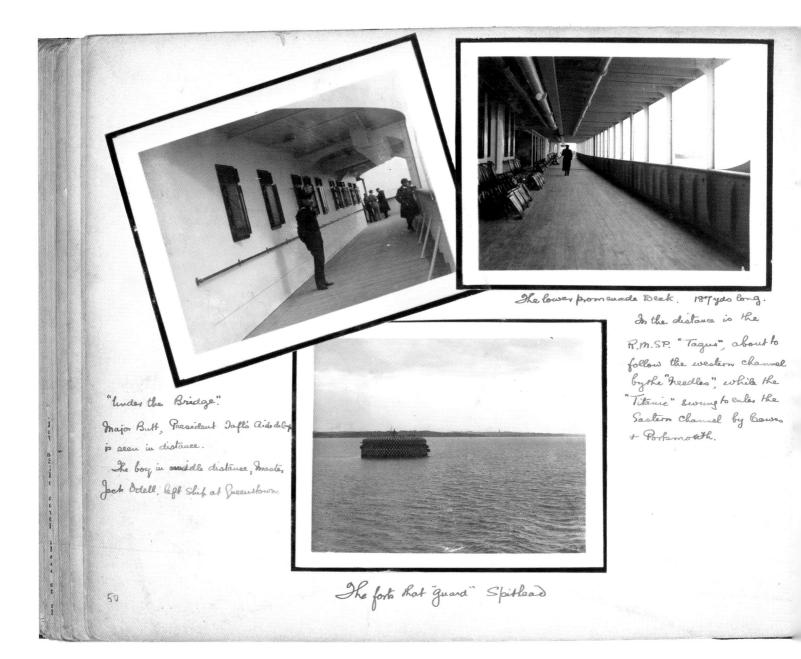

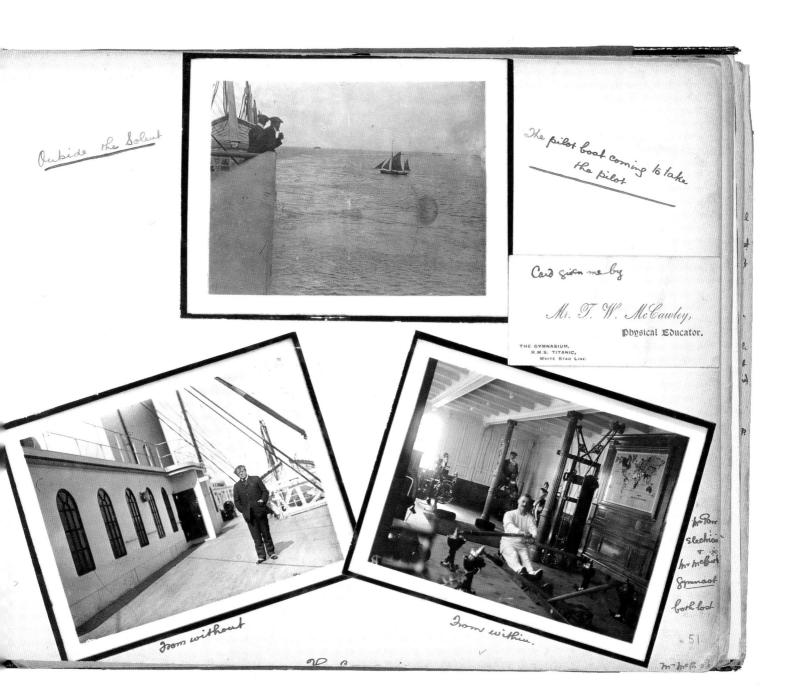

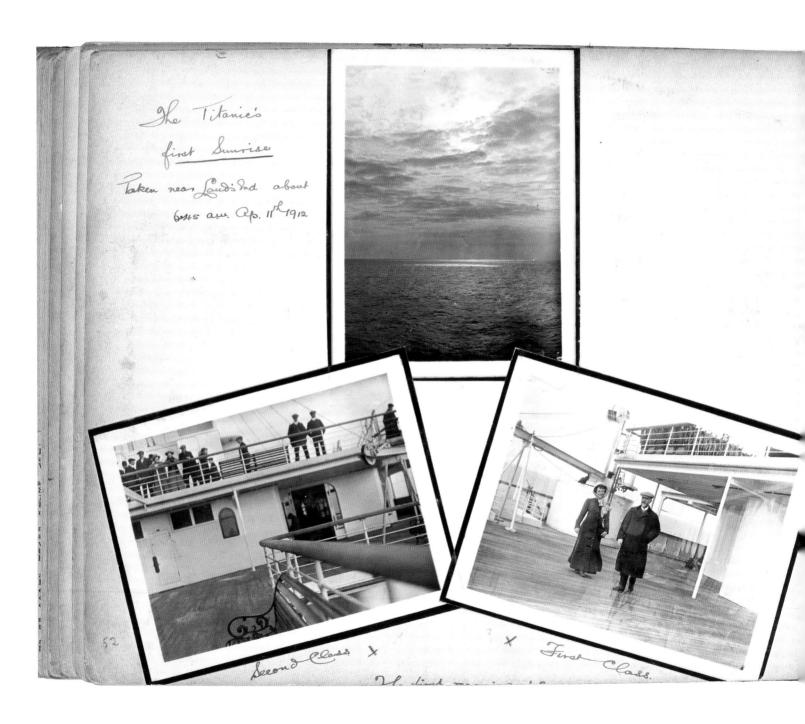

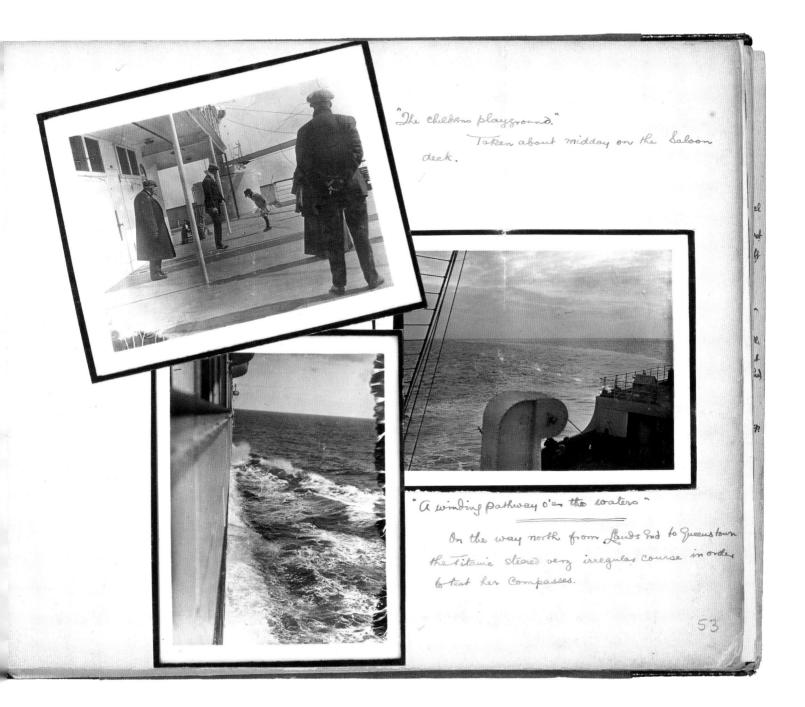

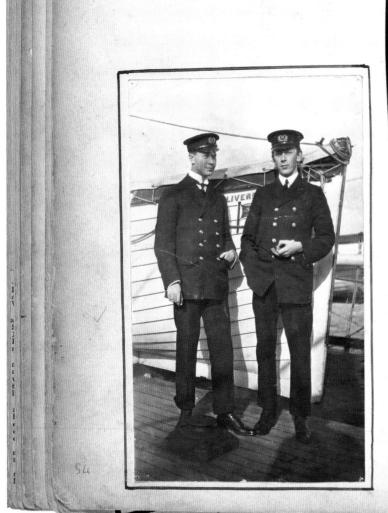

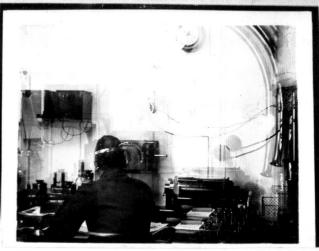

In the Marconi Room.

Mr Harole Bride, afterwards laved, Billing at the table.

Two eaposures on the one plate! This is the only photo ever taken of the Marconi room of the Titanie."

My Jack Phillips (on left), who was loot on the Titanie, faken shortly before his bansfer from the "adriatie"

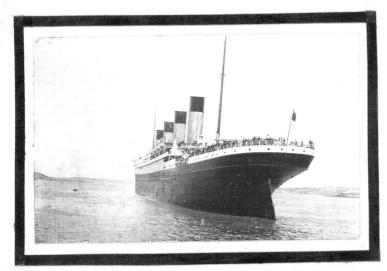

"waiting for the lender"

This photograph was taken from the lender "america", as she approached the Port Sauguay, bythe bythe of because arm. In it appears the stoker, whose appearance at the top of the fourth (dumming) funnel (which was in eality a huge ventilator) caused such construction.

The owner of this album is the centre

The owner of this album is the centre figure of the three immediately forward of the four after boats, on the boat deck.

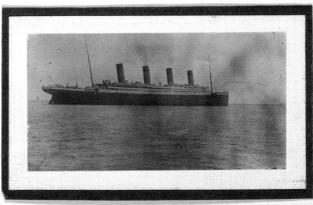

"Full Speed ahead for -

56 ...

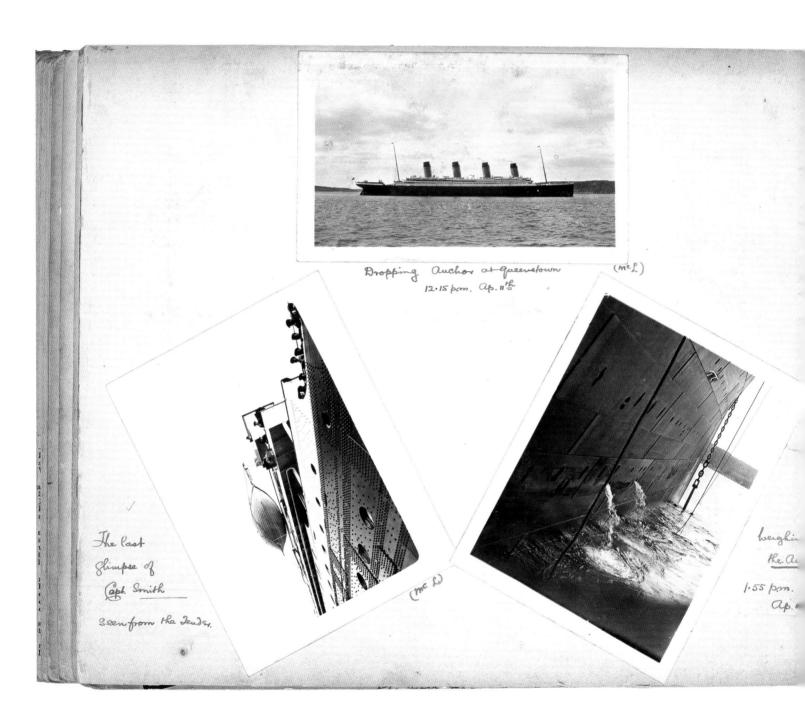

Queenstown Lathedral Monday Op. 22 w 7912

In memory of the Dead

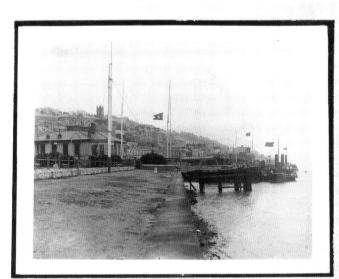

"White Star" "Cunard" Offices, Gueenstown, Fieday ap. 19th 1912.

Chapter 3

Journey to the *Titanic*

On 4 April 1912 Frank Browne received a letter from the White Star Line offices in Queenstown. Inside the letter an incredible surprise: a first-class ticket for the *Titanic*'s maiden voyage from Southampton to Queenstown via Cherbourg. The ticket, like his first camera, was a gift from Bishop Robert Browne.

Frank Browne would have needed special permission to go. At this time he was still in the middle of his theological studies at Milltown Park, Dublin. The status of his uncle Robert probably played a part in his being granted permission to go on the four-day trip.

On 8 April Frank travelled to London via Holyhead. It is probable that he spent the night of the 8th on the train south and the night of the 9th with his brother James in London. Dr James Browne lived just outside London and was the eldest of Frank's siblings. An eye specialist, he worked at Southwark Hospital.

Early on the morning of 10 April, Frank Browne travelled to Waterloo Railway Station in London to catch what he called the 'first and last *Titanic* Special' (p. 50). He took several photographs before leaving London, one of them captioned 'Mr Astor to see us off'. That caption – and the controversy surrounding it – is dealt with in the caption on page 51.

At Southampton railway station the Jesuit was met by his Irish friend, Tom Brownrigg, who accompanied him on board. After taking a photograph on the gangway, Frank Browne was handed a plan of the liner showing the location of the cabins and state rooms. Measuring a scarcely credible 40 inches by 30 inches, this huge plan was headed 'RMS *Titanic*'.

His own account of his famous journey from Southampton to Queenstown is given in full in chapter six.

White Star Letter, facing page: Note that despite the letter being addressed to 'Father Browne' Frank was not a priest at the time. He was due for ordination in 1915. The Irish mail service was a lot faster in 1912 than it is today. The letter with its precious enclosure would have been delivered to the Bishop's Palace on the afternoon of the 3 April, and from there sent on to Frank Browne in Dublin. It would certainly have made one of the three Dublin deliveries the next day.

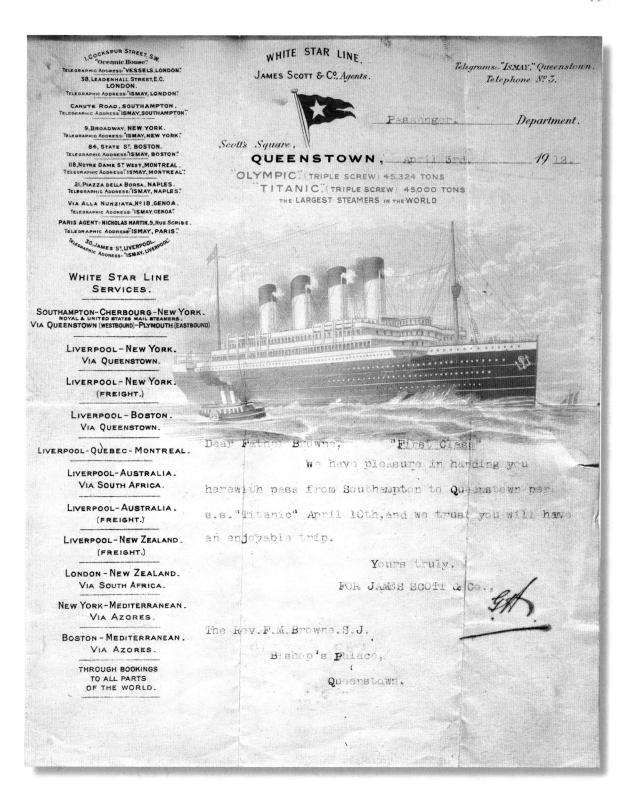

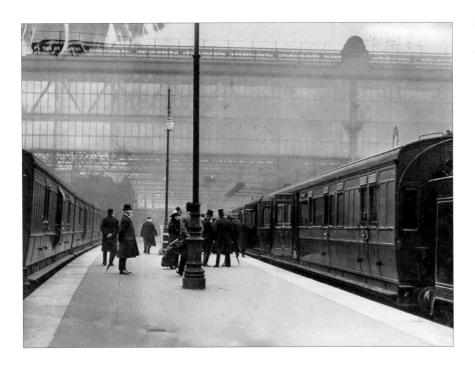

This photograph, and the following two, were taken at Waterloo Station, London, at 9.45am on Wednesday, 10 April 1912. Browne graphically describes the train as 'the first and last *Titanic* Special'.

To capture this image Browne has walked down the platform alongside the boat train (right) and turned to face back towards Waterloo Station. The man in profile on the left appears to be either Stanley or Richard May, two brothers who were travelling with Browne to Queenstown.

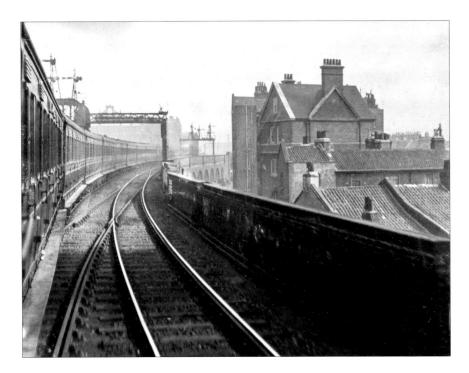

Frank Browne said that the Boat Train left Waterloo Station at 9.45am, yet several other *Titanic* passengers recalled afterward that the train departed as early as 8.00am. Presumably, the 'Special' was a non-stop express, which followed the earlier, scheduled train.

Here Browne has leaned far outside the window of the train as it rounded a curve immediately upon leaving the station. This same daring positioning of the camera would be used several times in later photographs.

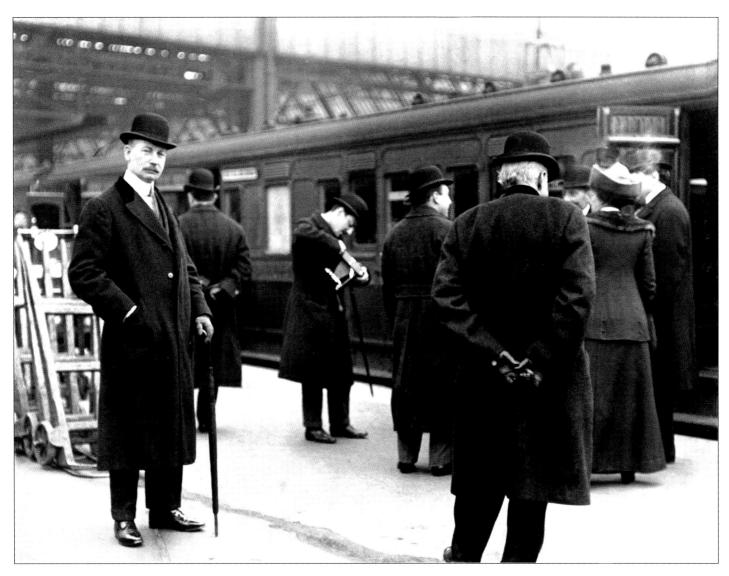

For many years it was thought that the gentleman on the left was John Jacob Astor, who perished in the *Titanic* disaster. Frank Browne's description, 'Mr Astor to see us off!' did not refer to John Jacob Astor who was not on the boat train, as he would not board the ship until it reached Cherbourg, France.

Recent research has shown that this is his cousin, William Waldorf Astor, who had moved to England from the United States in 1890. Owner of Cliveden and husband of Nancy Astor (the second woman to become a Member of Parliament), W. W. Astor would become Parliamentary Secretary to Lloyd George during the First World War and in 1919 would inherit his father's viscountcy.

Browne's Plan of the Titanic

Curiously, Frank Browne did not believe that the plan he received was of the *Titanic*. As can be seen from his notes (p. 55), he believed he had received a plan of the sister ship *Olympic*. The *Olympic* and *Titanic* differed in several respects. On the plan he received, there was no sign of state rooms A36 and A37. Browne penned them in himself. His own state room was A37. Thomas Andrews, managing director of Harland and Wolff, Belfast – the *Titanic's* builders – was in A36. With these rooms missing, Browne concluded that the plan was of the *Olympic*. In fact, he had received an early plan of the *Titanic*, dated December 1911. Although it did not show these state rooms, it did show a restaurant and some B-deck cabins that were not on the *Olympic*.

When I visited the Marine museum at Fall River, Massachusetts in January 1997, I was able to examine plans of both the *Titanic* and *Olympic*. The plans of the *Olympic* show two state rooms – curiously numbered A46 and A37 – where Browne had added them on his own early plan of the *Titanic*. These rooms must have been added to the *Olympic* when the liner returned to Belfast for modification after the *Titanic* disaster.

There is a curious energy about these two rooms – A₃6 and A₃7. Not only did they confuse Frank Browne, but when Dr Robert D. Ballard and his team found the wreck of the *Titanic*, they verified that the accounts given by survivors were true: the *Titanic* had split in half. The two sections sit almost two thousand feet apart. Where had the *Titanic* split, however? Directly through rooms A₃6 and A₃7, the quarters of Thomas Andrews and Frank Browne.

On this plan you will see there are seven distinct pictures. These are enlarged on pages 88 through 89. These, believe it or not, are in fact illustrations of the *Olympic*! They have been enlarged because they show several features that were identical on the *Titanic*.

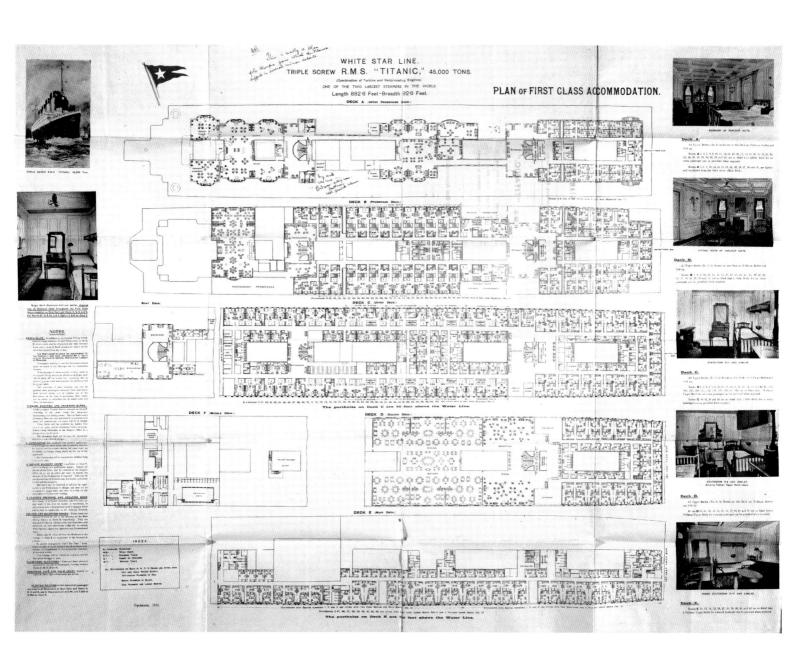

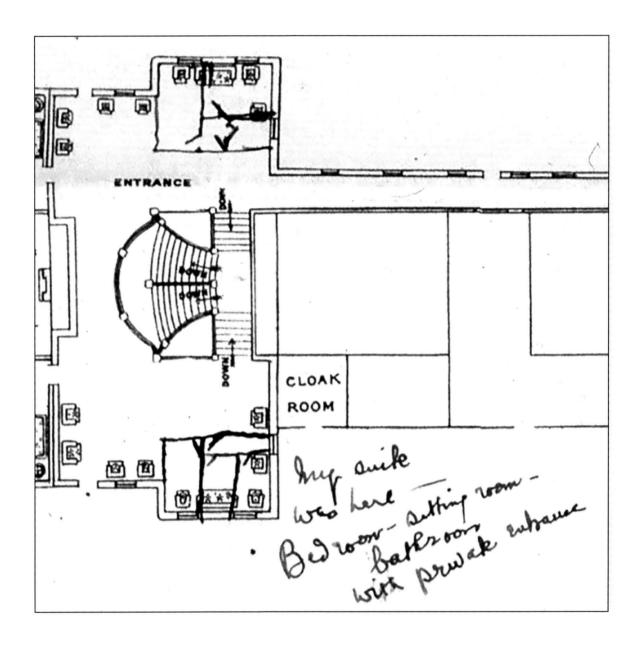

Handwritten notes on the plan:

'This is really a plan of the Olympic from which the *Titanic* differed in several minor details.'

'My suite was here - Bedroom - Sitting room - Bathroom with private entrance.'

MB. This is wally a plantie which the Thomas details.

TRIPLE SCREW

WHITE STAR

TRIPLE SCREW R.M.S. "TIT

(Combination of Turbine and Recipr

ONE OF THE TWO LARGEST STEAM

Length 882 6 Feet-Bread

DECK A (UPPER PROMENA

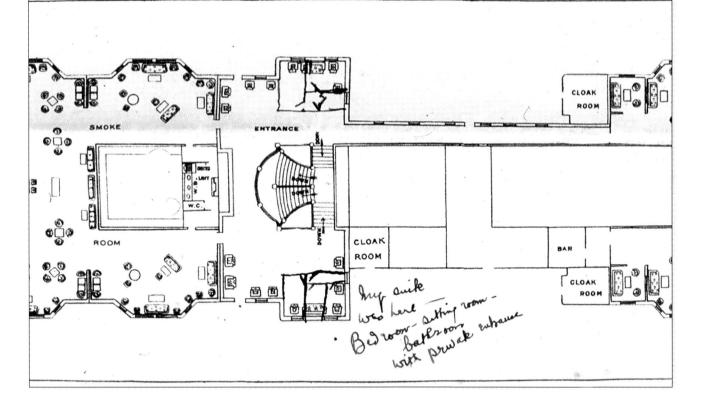

Chapter 4

The *Titanic* Photographs in Detail

Here the Titanic photographs are enlarged and an expanded commentary is included. Browne's own captions are annotated and corrected when necessary.

I am particularly grateful to Don Lynch and Ken Marschall who assisted me in putting this chapter together. Their knowledge of the *Titanic* and its history are second to none.

Any mistakes, however, are mine.

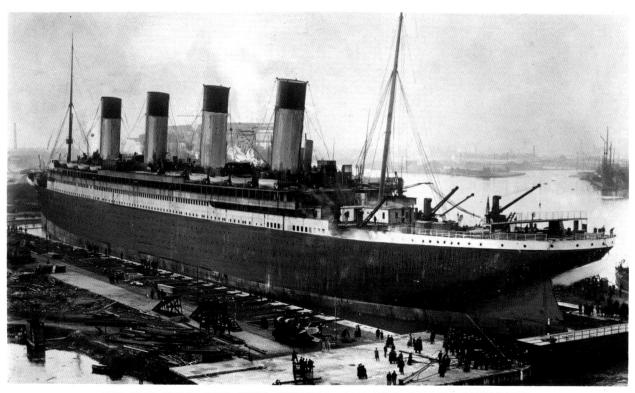

THE NEW WHITE STAR LINER "TITANIC" (45,000 TONS) NEARING COMPLETION; DOCKED IN THE LARGEST GRAVING DOCK IN THE WORLD. BELFAST, FEBRUARY 1912.

Although captioned as the *Titanic*, this postcard is actually her sister ship *Olympic* under construction at Harland and Wolff Ltd in Belfast. Normally the most noticeable difference between the two ships was the Titanic's enclosed A-deck promenade. However, at this point in their construction, both ships had this promenade open. In this photograph the B-deck promenade is open at the aft end for a greater length than the *Titanic's*, and while on the *Olympic* B-deck was, like A-deck, a promenade, on the *Titanic* it had staterooms with only two short private promenade decks for two of the suites. Quite irresponsibly, it was not unusual for photographs of the Olympic to be substituted for the newer, less photographed, *Titanic* when postcards were being produced.

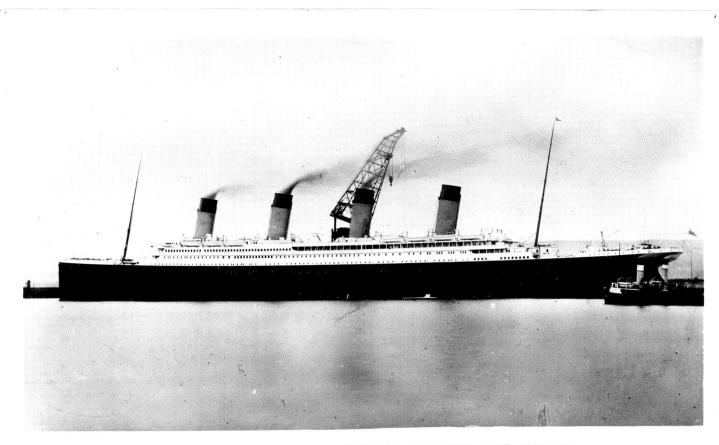

WHITE STAR LINER R. M. S. "TITANIC" LAUNCHED 31 ST MAY 1911, SUNK OFF CAPE RACE ON MAIDEN VOYAGE, 15 TH APRIL 1912, 1565 PASSENGERS LOST.

Unlike the previous postcard, this one was purchased after the *Titanic* disaster, as evident from the printed caption on the face. In this case it is a photograph of the *Titanic* and not her sister, taken at Harland and Wolff. She appears to be about to set sail on her trials on Tuesday, 2 April 1912. There are tugs waiting at her stern, smoke is coming from her funnels and water is pouring from the condenser exhaust on the side of the ship. Judging by the way the smoke appears as a blur in the photograph, it is apparent that this was a time exposure of at least several seconds.

The caption states that 1,565 passengers were lost in the disaster. This is untrue. Nobody knows exactly how many people lost their lives because there is a great deal of uncertainty as to how many passengers travelled steerage and how many crew members there were altogether. Lists of survivors and of casualties give the same person's name sometimes twice, sometimes three times, with different spellings. All we can say for sure is that a total of over 1,520 people, including crew as well as passengers, lost their lives.

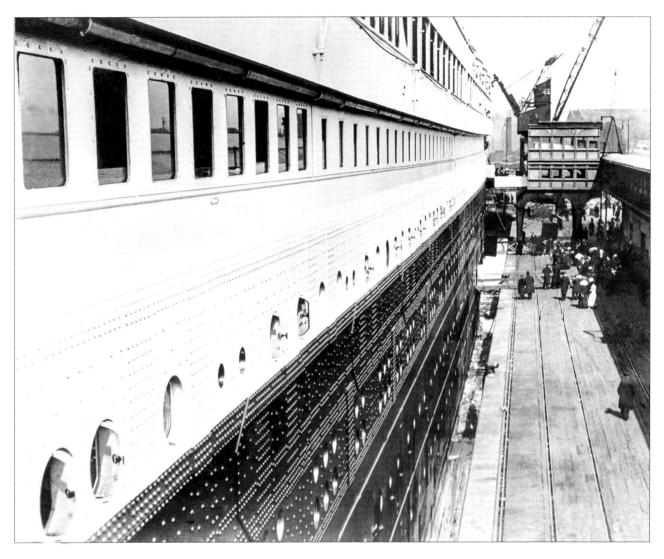

As he is just about to board the *Titanic*, Frank Browne has taken this image looking down the length of the ship. In the distance is the second-class gangway, identical to the one on which he is standing. The two structures were built specifically for passengers to board the *Olympic*, *Titanic* and their forthcoming third sister, *Gigantic* – subsequently named *Britannic* – which were all much taller than any ship in existence. The third-class passengers are boarding from a lower gangway, which is slightly below wharf level. On the dock the massive bollards, apparently freshly coated with glossy paint, reflect the sunlight. These bollards, and the railroad tracks, are still on the wharf today although the terminal building is long gone. The large square portholes in the upper left are the private promenade deck of the suite occupied by Mr J. Bruce Ismay, Managing Director of the White Star Line. Only two of the suites on the ship had their own promenades.

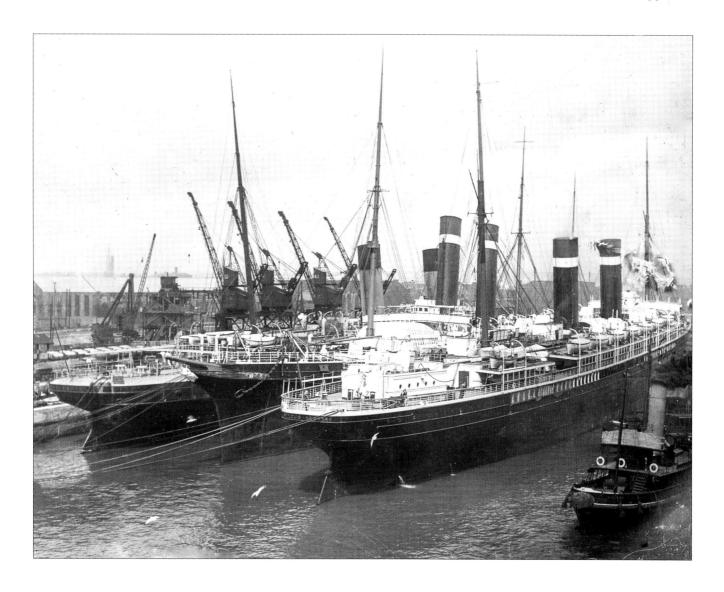

These three ships, the *Saint Louis* and the *Philadelphia* (both of the American Line) and the *Majestic* (White Star Line), had their voyages cancelled by the coal strike which had occurred in England that spring. Their coal was used for the *Titanic*. Their passengers, and many of their crewmen, were also transferred to the new White Star liner. At the right of the photograph a tug is approaching, so we know that the ship is just casting off. This view is apparently looking aft from the starboard boat deck at the moment of departure.

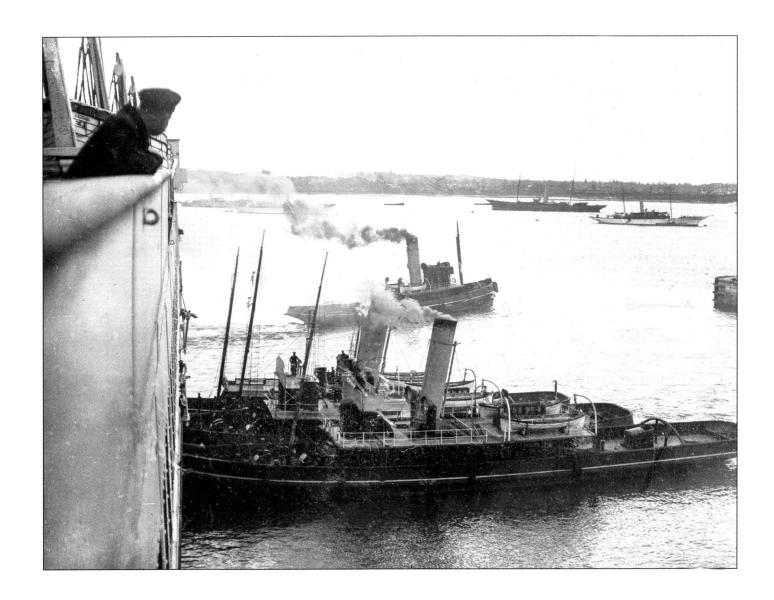

Frank Browne has now turned from taking the previous photograph and is facing forward. He has leaned out over the side of the ship with his camera to capture more of the tugs below. In the distance is the far shore of the River Test, with some private yachts at anchor in between. On the left of the photograph is lifeboat number seven. It would be the first to be launched as the ship sank. The tugs in the foreground, *Neptune* and *Hector*, can be seen more clearly on page 62.

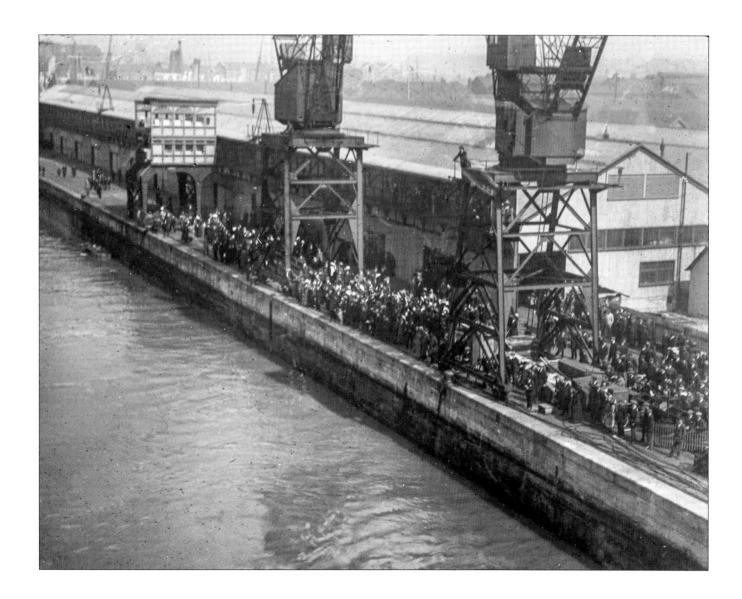

Moving over to the port side of the boat deck, Frank Browne captures a crowd of mostly local citizens seeing the liner off. This is one of the few known photographs of the new terminal building in its original paint scheme. Completed in 1911, the building would soon after be painted in London and Southwestern Railway's green livery.

The Ocean Terminal still exists at Southampton today but the railway station has been demolished. Different cranes are now at work but the quayside bollards remain unchanged.

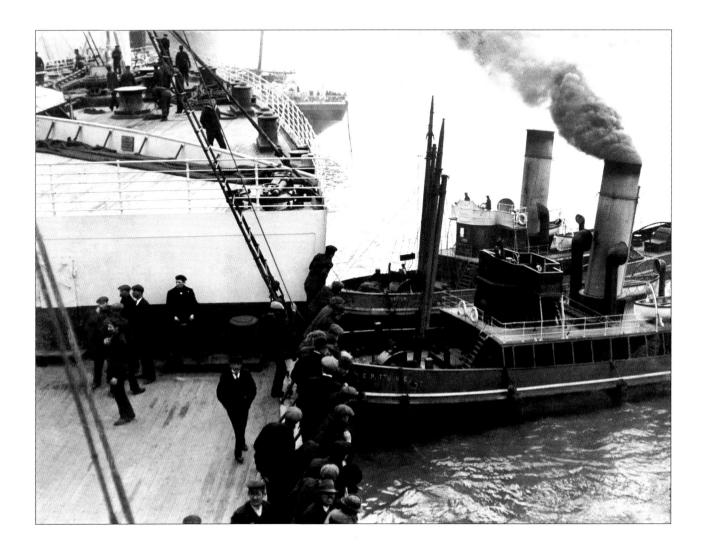

Browne has now moved over to the starboard bow of A-deck where the tugs *Hector* and *Neptune* can be seen nudging the ship's bow. In the distance the stern of the liner *New York* has swung out in front of the *Titanic*. On the forward well deck, third-class passengers and off-duty crewmen also watch what is happening below.

This is the only known clear photograph of the *Titanic's* forecastle deck. Because this part of the ship was the first to sink under the sea, and did so slowly, it is largely intact on the bottom of the ocean. All of the fittings visible in the photograph are on the wreck today, including the kedge anchor, which is still bracketed securely to the deck as shown here. Even the railings are the most intact of any on the wreck. The large capstan is where Dr Robert D. Ballard deposited a memorial plaque during his dives to the *Titanic* in 1986.

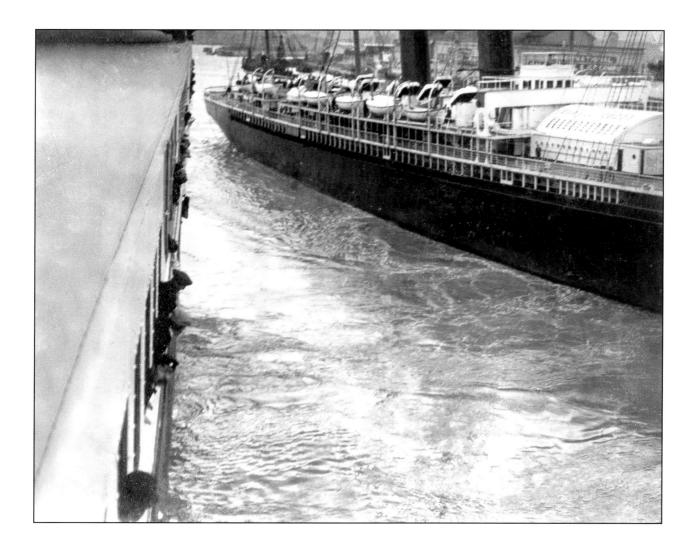

Once again the camera is held out from the side of the ship. Either Frank Browne himself is leaning far out, or he is holding the camera at arm's length. The *Titanic* has already rounded the end of the jetty where, as it passed the American liner *New York*, the latter broke free from its moorings and began to swing around towards the larger ship.

This photograph was taken from the port side of the boat deck, and below on A-deck, passengers can be seen leaning out from the large promenade deck windows to see the anticipated collision. Like many of the other ships docked in Southampton, the *New York's* voyage had been cancelled because of the coal strike.

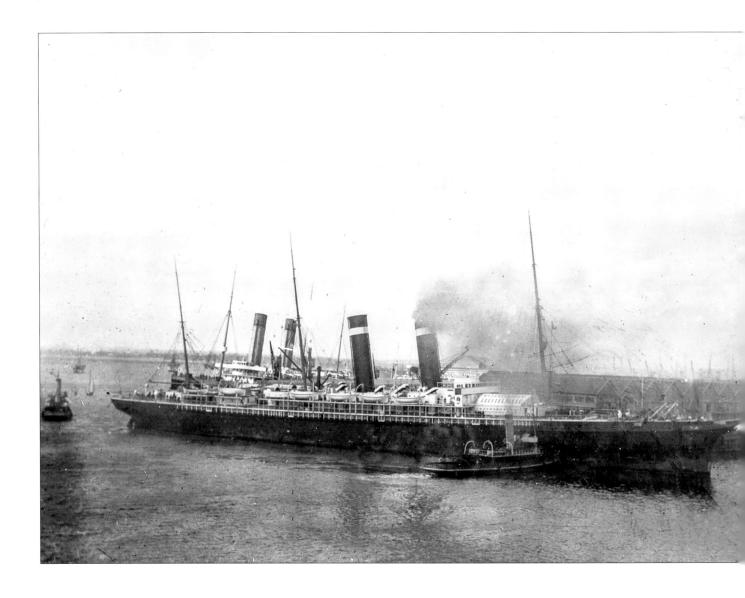

The *New York* is being pushed by a tug into a temporary position at the end of the quay. Behind it the *Oceanic*, also in dock due to the coal strike, can be seen at its moorage. This is the only Frank Browne photograph in this sequence in which the *Oceanic* appears. Minutes earlier the *New York* was moored alongside it. Both ships, when new, were among the largest liners in the world, and yet it is obvious how they are dwarfed by the *Titanic*.

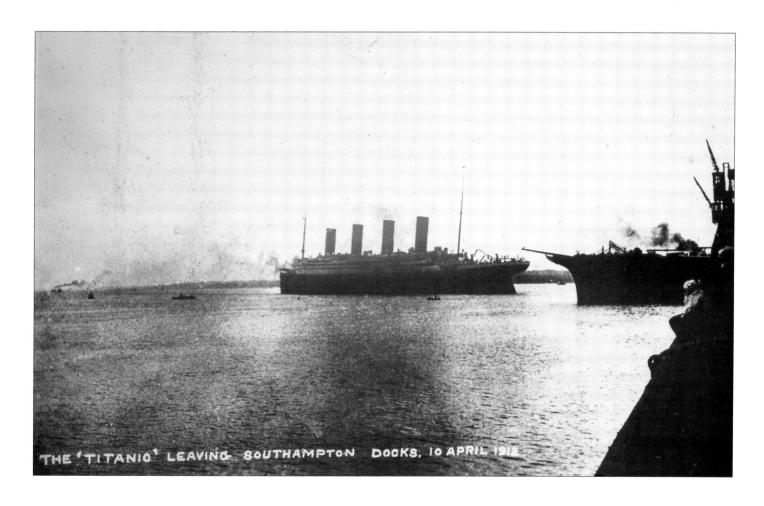

This is the third and last of Frank Browne's valuable postcards. The photograph, taken by F. J. Arnott, shows the tug *Vulcan* alongside the *Titanic*. The ship was delayed for an hour on leaving Southampton after its near collision with the *New York*. This delay has always been attributed to the close call itself, yet this photograph shows the bow of the *New York* as it is being swung back into position alongside the *Oceanic*. Clearly the crisis is over. Frank Browne's description of this incident in *The Belvederian* – see chapter six – coupled with this photograph, offers a more likely explanation: some workmen had failed to heed the 'All Ashore' call, and, taking advantage of the ship's stopping after her narrow escape, the *Vulcan* has to be summoned to take them off. The tug is difficult to see in this postcard, but it is lashed to the *Titanic* beneath funnels three and four.

On A-deck, just below the bridge, Frank Browne snaps the only known photograph of this section of deck on either the *Titanic* or *Olympic*. The boy on the right is Jack Odell, another member of the family with whom Frank Browne is travelling, and in the distance is Major Archibald Butt, military aide to President William Howard Taft. Overhead, a box-like structure conceals the mechanical linkages for the bridge instruments, while on the left are stateroom windows made of particularly heavy-duty brass to withstand any rough weather the ship may face.

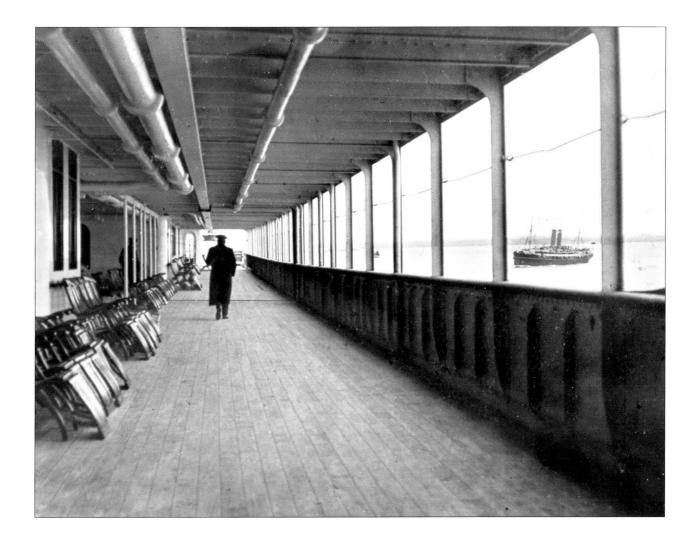

Still on A-deck, Frank Browne has crossed over to the port side and walked aft. This image was taken right at the point where the enclosed section of deck gives way to open promenade. The curve on the railings at right shows where the enclosed windows begin. The cable which stretches above the railings is for a canvas shade, which appears in photographs taken later at Queenstown. The lone figure on the 187-yards-long deck has been described as Captain Smith, yet Frank Browne's album makes no mention of this; a comment he would not have overlooked. It is also highly unlikely that the Captain would not have been on the bridge with the harbour pilot as they still have not reached open water.

In the distance is the Portuguese ship, RMSP *Tagus*, which is about to follow the Solent's western channel by the Needles. The *Titanic* itself will swing left to follow the eastern channel by Cowes and Portsmouth.

One of the forts that guard Spithead – No Man's Land Fort in the Solent. This is one of the three sea forts, known as 'Palmerston's Follies', that guard Portsmouth. The armament was two 6-inch breech-loading guns and two 4.7-inch. The fort was manned by two officers and twenty-seven other ranks. An interior artesian well supplied 1,400 gallons of water per hour. Although they were of considerable strategic importance during both World Wars, none of these forts ever fired a shot in anger.

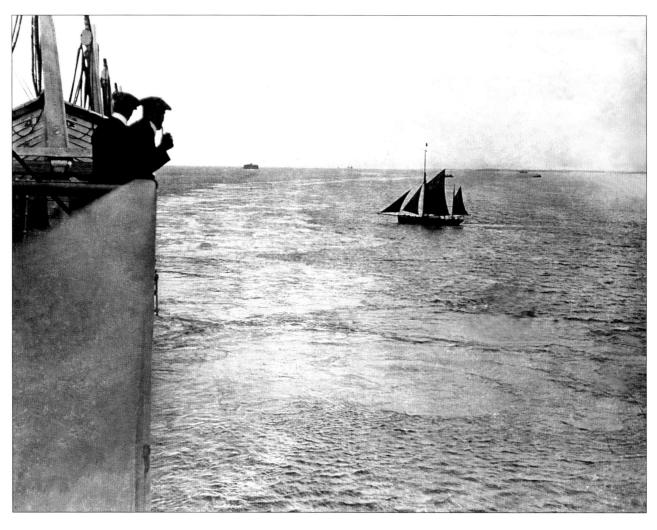

Bottom, facing page: Looking aft from the port side of the boat deck, the channel fort in the previous photograph has now been left astern. Newspapers described this as dropping the pilot at Portsmouth, where he will be taken ashore by an Isle of Wight boat. This may be based upon Frank Browne's description that this shows the pilot boat coming to take the pilot. Judging by the ship's wake which shows that the Titanic is apparently under way and moving quite quickly, the probability is that the pilot has already been dropped. Once again Frank Browne is leaning over the railing to take his picture. The lifeboat shown is number ten. This is one of the very few photographs of a Titanic lifeboat so clear as to show the ship's name. 'S S Titanic' appears on the outboard side, and 'Liverpool' on the inboard.

The *Titanic's* first sunrise. Taken near Land's End, Cornwall, on the voyage between Cherbourg and Queenstown, about 6.45am on 11 April 1912. As a Jesuit 'scholastic' (i.e. student for the priesthood), Frank Browne would have been making his morning meditation at this hour. What better place to make it than on the deck of the *Titanic*?

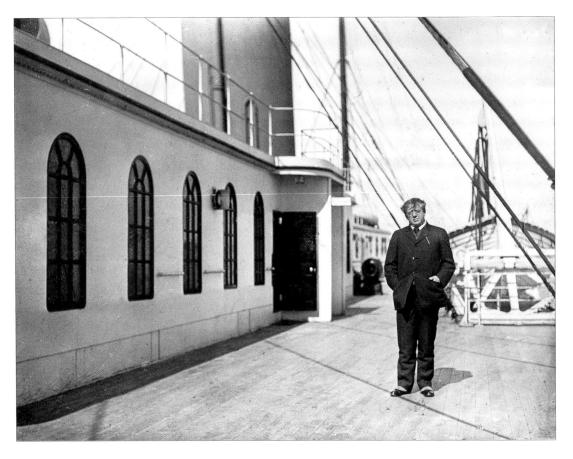

This is apparently American short story writer Jacques Futrelle, standing on the boat deck outside the *Titanic's* gymnasium. The author of the popular 'Thinking Machine' mysteries, he had a number of unpublished stories on board with him which would be lost forever. Having turned thirty-seven only the day before sailing, he would lose his life in the disaster.

On the right can be seen lifeboat seven again, the first to be launched after the collision. In the distance, on the roof of the officers' quarters, is collapsible lifeboat A, which would be the last to leave the ship. Floating from the deck, it would be swamped and would rescue only a handful of people, including the only woman to swim away from the ship and survive.

In the centre of the photograph is the illuminated sign-box which identifies the first-class entrance. Just inside is the beautiful grand staircase, with its carved panelling and dome overhead. The windows on the left are those of the ship's gymnasium into which Frank Browne is about to step. Curiously, some of the handrails between the windows have not been installed.

Facing page: The gentleman in white flannels is T. W. McCawley, the thirty-fourvear-old 'physical educator' from Aberdeen. Another cross-channel passenger would vears later recall McCawley as 'rather strict in general with the passengers' but that he softened his demeanour for the children on board. Under his charge is the room filled with the most modern gymnasium equipment available. Unlike many sterile gymnasia of today, the walls are white-painted pine, with an oak-panelled wainscotting. On the right is an illuminated glass painted map showing the routes of the White Star liners around the world.

The man in the far corner may look like he is enjoying riding the mechanical camel, but he likely considers himself hard at work. He is electrician William Parr, one of the representatives of Harland and Wolff shipbuilders travelling firstclass for this maiden voyage. The electrically driven camel had received quite a workout from people touring the ship at Southampton, and William Parr may be ensuring that it continues to work properly. Both men would perish in the sinking, Mr Parr being survived by his wife of less than two years and a tiny baby. The final two words of Frank Browne's caption (p. 41) read: 'Both lost'.

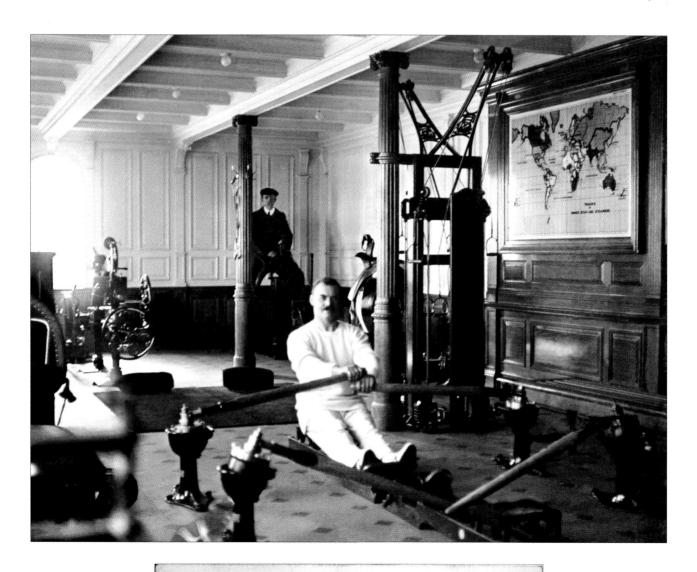

Card given me by

Mr. T. W. Mc Cawley,

Physical Educator.

THE GYMNASIUM,
R.M.S. TITANIC,
WHITE STAR LINE.

Taken from the aft end of A-deck, this photograph is looking forward towards the rear of the ship's superstructure. On the deck above, a group of second-class passengers stare back at the camera. The *Olympic* and *Titanic* were unusual in that second-class passengers, who claimed the very aft end of the boat deck for their promenade space, could look down on first-class people, who had the entire A-deck to themselves. The next deck below is again second-class.

The sliding double doors lead into the starboard Verandah and Palm Court, which would become an unofficial playroom for the small children in first-class accommodation. To the right a small cargo crane is visible and Browne's reflection can be seen in the window directly in front of the camera.

Facing page: Stepping forward a few feet, and turning to the left, Frank Browne has encountered an unidentified couple taking an early stroll. The port cargo crane is much more visible here than the starboard one was in the previous photograph. Overhead, deck-chairs are stacked against the railing of the second-class promenade. The absence of clearly defined shadows shows that it was overcast this morning.

An unusual facet of this photograph is that it is a doubleexposure. Barely visible is the wicker furniture of the starboard private promenade, part of a suite occupied by Mrs Charlotte Drake Martinez Cardeza, a Philadelphia millionairess and big game hunter who had boarded at Cherbourg the previous evening. Flowers, possibly a bouquet wishing her bon voyage, grace one of the tables. The door leading from this promenade into the first-class entrance-way must have been open for Frank Browne to have taken this image as he surely did not know Mrs Cardeza, although she was famous for having the most luggage of any passenger aboard. (Her fourteen steamer trunks contained seventy dresses, ten fur coats and ninetyone pairs of gloves).

On the infamous night of April 14, Mrs Cardeza and her son, along with their valet Gustave Lesueur and maid Annie Ward, left the sinking ship in lifeboat three. Not surprisingly, Mrs Cardeza was the *Titanic's* largest insurance claimant.

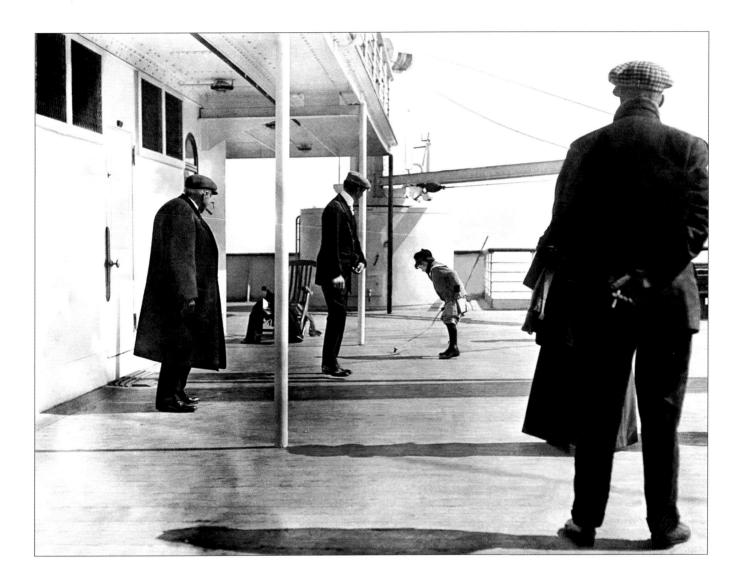

This photograph is taken from virtually the same location as the previous one. It is now later in the day and Frank Browne is facing starboard instead of port. In the centre is six-year-old Robert Douglas Spedden of Tuxedo Park, New York, spinning a top while his father, Frederic, watches.

Both father and son, together with Mrs Spedden and their two servants, would survive the sinking but Frederic's photographs – taken with the camera seen here on shoulder-strap – did not. Three years later Robert would be struck and killed by a motor-car in Maine, USA, ironically a victim of modern transportation after all. In a similar irony, his father Frederic would later drown, suffering a heart attack in a swimming-pool in Florida in 1947.

Still aft on A-deck, Father Browne has now walked over to the starboard railing and is facing forward. He may be leaning out over the rail, as he has done in order to take other photographs, but given the uneven horizon he is more likely holding the camera out at arm's length. Just above, the bottoms of two lifeboats can be seen. The aft boats were cranked slightly outward to allow more promenade space for second-class passengers on the boat deck above. In the distance, an emergency boat - number one - can be seen hanging over the ship's side. It, and boat two on the port side, were swung completely out immediately after leaving Southampton so that they could be lowered easily in the event of someone falling overboard. This particular boat would later carry Sir Cosmo and Lady Duff-Gordon to safety on the night of the sinking.

The wake trailing off to starboard confirms Frank Browne's description of the 'winding pathway o'er the waters', and that an irregular course was being taken in order to test the compass. He is still on the aft end of A-deck, but has now walked to the railing at the far end where he looks over the well-deck. Some third-class passengers can be seen at the bottom centre of the photograph, while the head of a large cargo crane dominates the lower foreground. The photograph confirms that there was no question of the *Titanic* trying to break any speed record between Cherbourg and Queenstown. Incidentally, it was into this well-deck that large chunks of iceberg fell on the night of the collision.

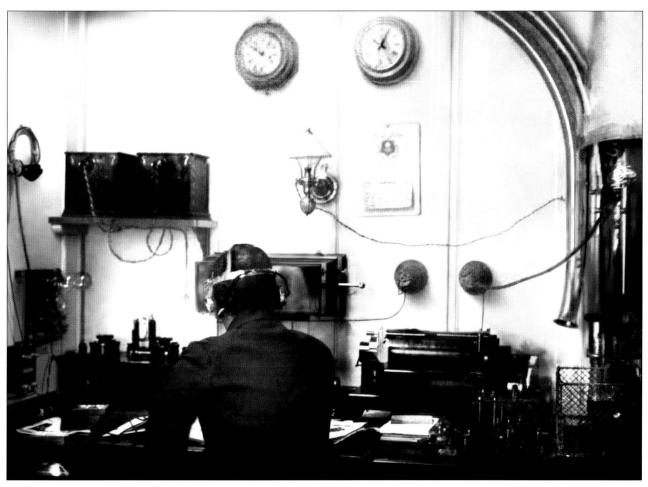

The *Titanic's* junior wireless operator, Harold Bride, is shown here at his post. This is a corrected photograph of the double-exposure pictured right, and one that Browne was going to throw away until, after the disaster, he learned that it was the only picture ever taken in the liner's Marconi room. The wireless equipment on the *Titanic* was the most modern afloat, and the most powerful of any merchant vessel. She had a guaranteed range of 350 miles, but in actuality could transmit and receive messages at a range of 500 miles during the day and a thousand miles away at night. While at Belfast she had been exchanging messages with stations on the Canary Islands off the coast of Africa, and Port Said in the south-eastern Mediterranean.

Passengers did not normally enter the wireless room as Frank Browne has done, but deposited their messages and payment for such with the purser's office. They were then sent to the operators by pneumatic tube. This tube can be seen on the right, below which is the basket into which the container holding the messages could drop. Like Jack Phillips, Harold Bride would heroically stay at this post the night of the disaster. Unlike his coworker, Mr Bride would have a remarkable escape in that he swam away from the sinking liner as it took its final plunge, and then clung to an overturned collapsible boat with a group of other men until he was rescued the following morning.

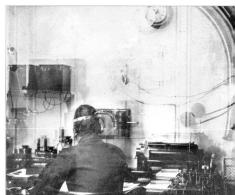

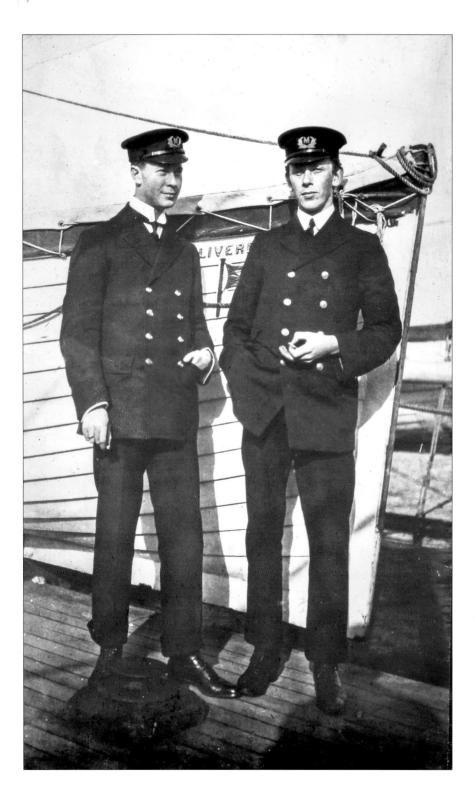

Taken aboard the *Adriatic* prior to Frank Browne's voyage on the *Titanic*, the photograph shows two wireless operators. The gentleman on the left is Jack Phillips, who would stick to his post on board the *Titanic* summoning rescuers for those who, unlike himself, were leaving the ship in lifeboats. One of the undisputed heroes of the disaster, there are memorials on both sides of the Atlantic erected in his memory. It is ironic that Frank Browne placed this photograph in his album amongst those he took on board the *Titanic* on 11 April, for that was the date of Phillips' twenty-fifth birthday.

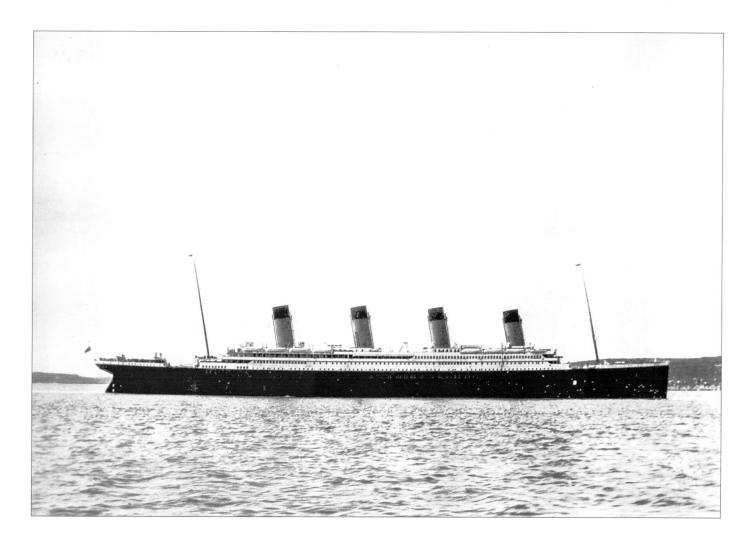

Frank Browne described this view as the ship 'dropping anchor', but the wake at her stern shows her to be still under way. She is surely about to stop, however, for already a gangway door in her hull has been opened, below the forward well-deck. The liner's flags fly proudly from masts and stern, while along the A-deck aft promenade can be seen the canvas shade described earlier. This beautiful broadside shot was taken from the tender *America* by a Mr McLean of Queenstown.

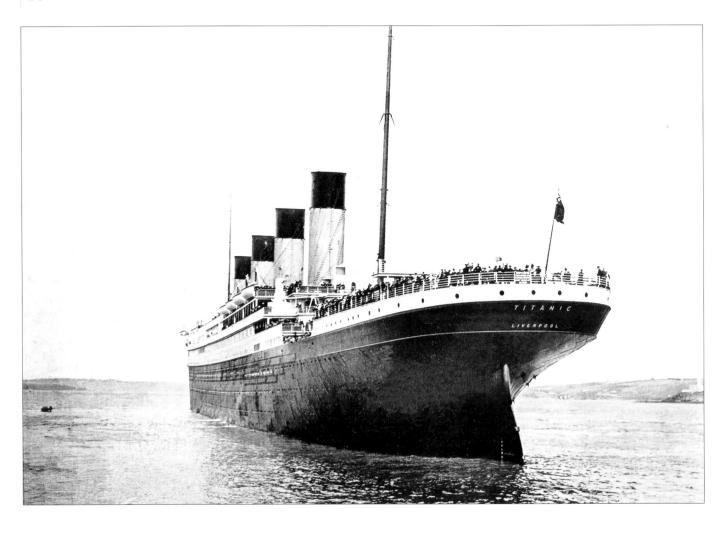

Third-class passengers throng the stern of the ship, where can be seen a sign warning of the danger of the propellers below. A tiny dot at the top of the fourth funnel – which is, in fact, a huge ventilator – is the grimy face of a stoker who climbed up for a bird's eye view of the Irish port, and who to some seemed like the black spectre of death looking down. The superstitious among the passengers saw this as an ill omen. Off to the right is Roche's Point, while on the port side of the ship can be seen 'emergency' lifeboat number two, swung out in case it is needed. This would be the first lifeboat rescued by the *Carpathia*.

This photograph was taken from the tender *America* as she approached the port gangway by Mr Whyte of Queenstown. Frank Browne is the centre figure of the three seen against the skyline near the forward mast.

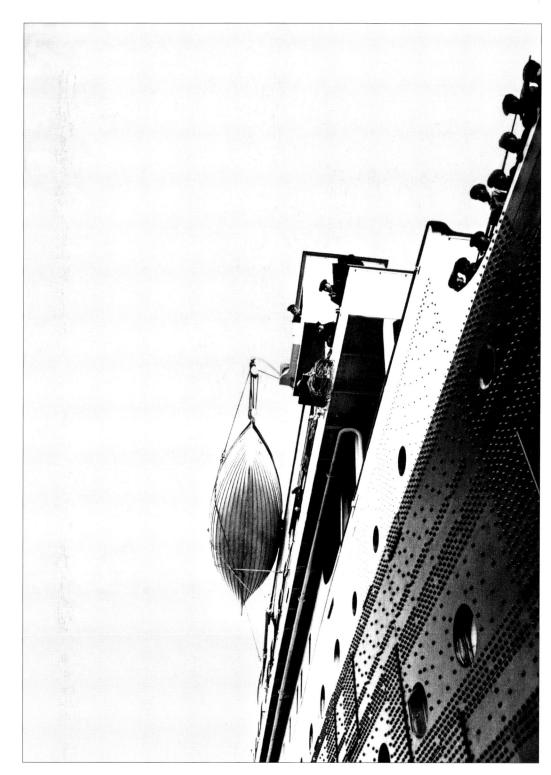

The tender America has now pulled alongside the open gangway door, and looking up, Mr McLean has photographed Captain Smith looking down from the starboard bridge wing, with the leadsman's platform underneath and slightly forward of him. At the edge of the photograph numerous third-class passengers are looking down at the tender, while first-class passengers watch from the deck below the bridge. The 'emergency' lifeboat number two dominates the photograph.

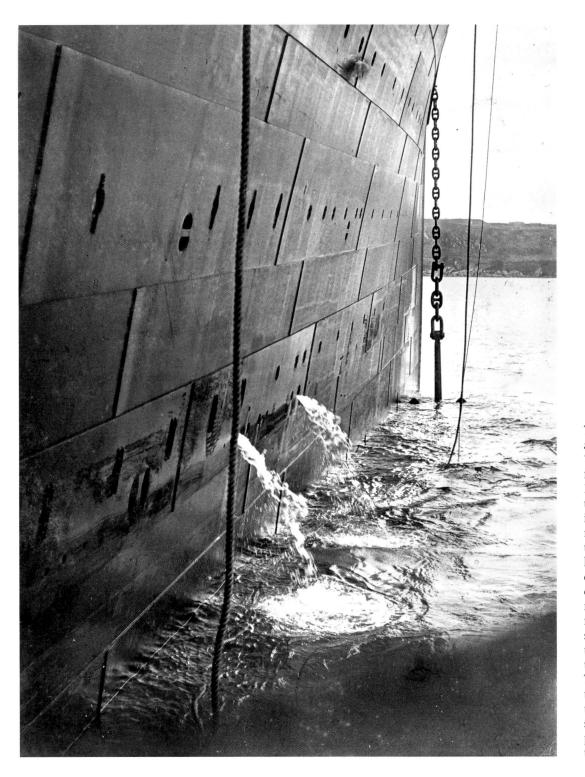

The giant starboard anchor of the Titanic is raised for the last time. In Queenstown terms (i.e. using imperial, not US measurements), the liner used a length of six cables of wrought-iron chainwork. A cable measured fifteen fathoms, so it took several minutes for the anchor to come to the surface. Taken at 1.55pm on the 11 April 1912, the photograph shows the very plates that struck the iceberg.

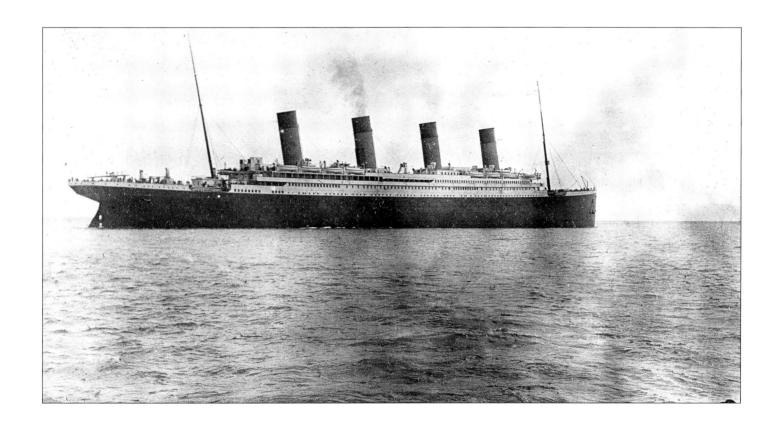

The anchor is now up and the *Titanic* is slowly steaming out of the harbour. The sun shade, visible along A-deck in the centre of the ship, will likely be raised before the ship reaches full speed and the resulting wind tears at it. This is one of the last photographs ever taken of the ship. The very last one is shown on page 101.

Chapter 5

The *Titanic* Photographs in Context

In this chapter you will find a collection of photographs that help to contextualise the famous *Titanic* album. They fall into three different categories.

First, there are pictures of the *Titanic* taken by Browne that he did not include in the album. Presumably, he didn't think them of high enough quality to include.

Secondly, there are pictures taken by Browne aboard the *Olympic* – the *Titanic's* sister ship. These pictures show parts of the *Olympic* that had identical counterparts on the *Titanic*.

Thirdly, there are the enlarged photographs taken from the plan of the ship that Browne received in Southampton (pp. 53–55).

Finally an enlarged detail of one of Frank Browne's *Titanic* photographs made by David Davison is included. This is the last extant picture of Captain Edward Smith and, in order to be faithful to the integrity of Browne, it is a 'natural' enlargement in the sense that no artificial photoenhancement technique has been employed.

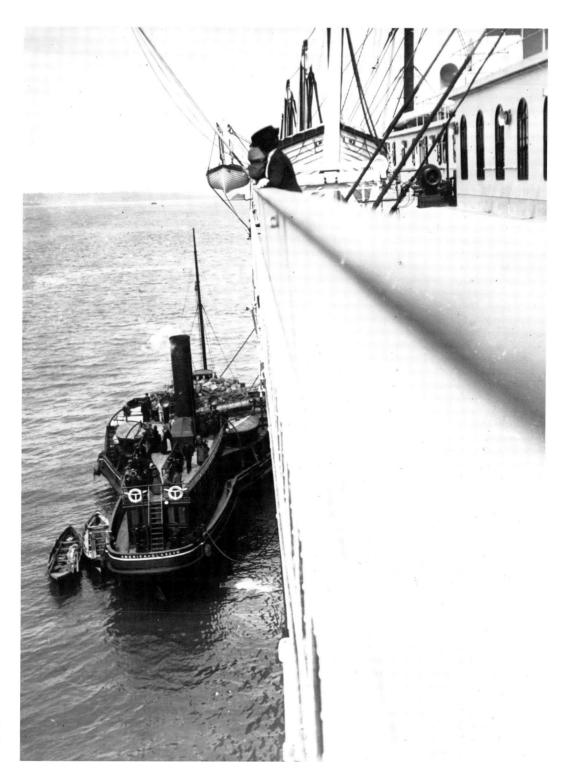

The *Titanic* and the tender *America*.

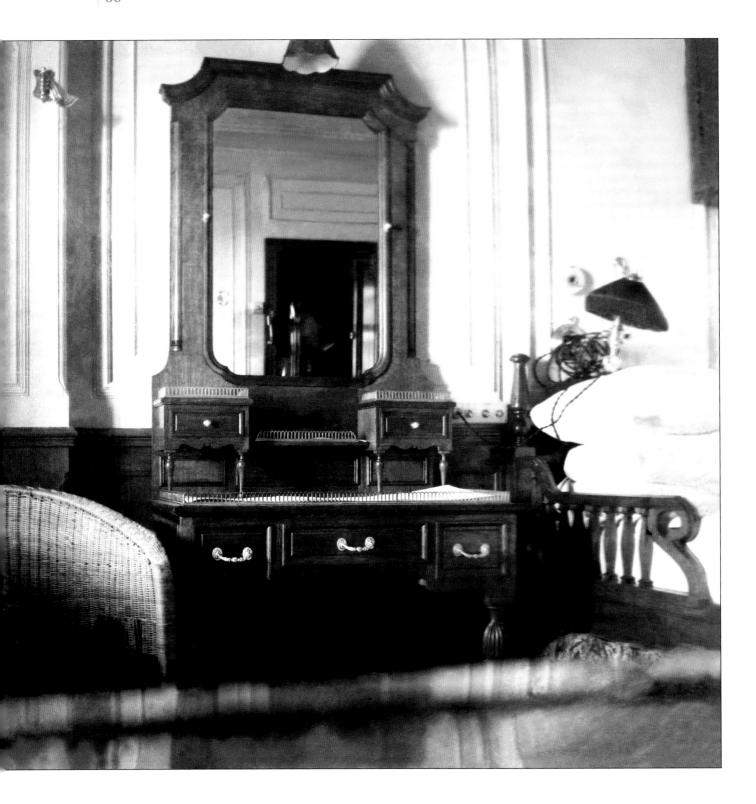

Facing page:
The bedroom
section of
Frank Browne's
suite of rooms,
numbered A37,
aboard the
Titanic. On
pages 54 & 55
we saw how
he drew in his
'suite': bedroom,
sitting-room,
bathroom –
with private
entrance.

This page:
Another view of
Frank's bedroom
but this time
the negative
was consigned
to his 'morgue'
and would
probably have
been consigned
to the trash-can
had the liner
survived. Browne
thought it too
fuzzy to include
in his album.

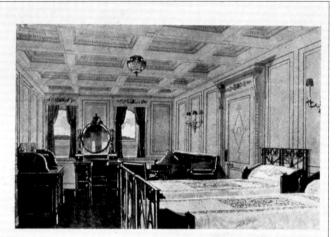

BEDROOM OF PARLOUR SUITE.

Deck A.

All Upper Berths (No. 2) in Rooms on this Deck are Pullman Berths and fold up.

 $\mathbf{Rooms} \ \pmb{\mathsf{A}}\ 5,\ 6,\ 7,\ 8,\ 9,\ 10,\ 11,\ 12,\ 14,\ 15,\ 16,\ 17,\ 18,\ 19,\ 20,\ 21,\ 22,\ 23,\ 24,$ 25, 26, 27, 28, 29, 30, 31, 32 and 33, are so fitted that a Sofa Berth for an extra passenger can be provided when required.

Rooms A 5, 6, 9, 10, 14, 15, 18, 19, 22, 23, 26, 27, 30 and 31, are lighted and ventilated from the Deck above (Boat Deck).

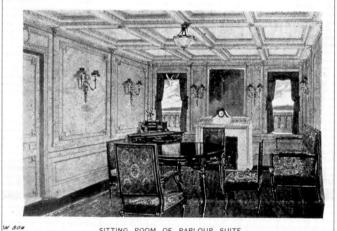

SITTING ROOM OF PARLOUR SUITE.

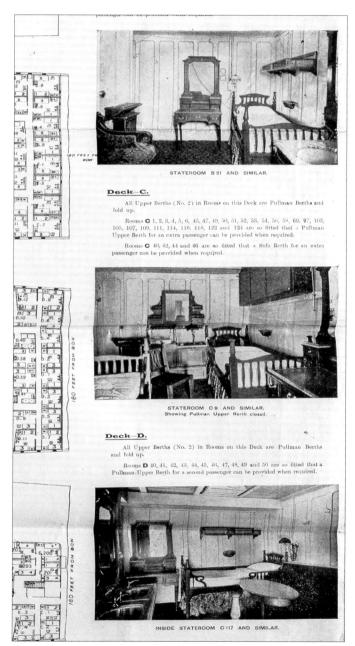

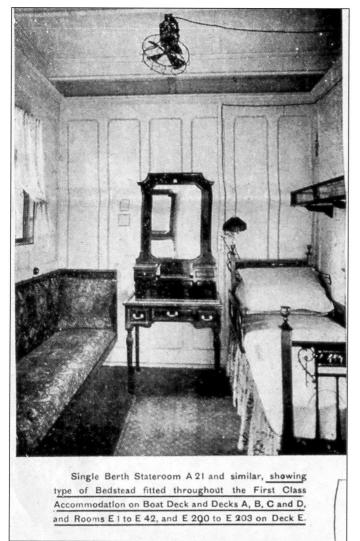

Enlargement of the photographs shown on the plan of the liner which Frank Browne was handed when he boarded *Titanic*.

The first-class dining room of the *Titanic*. Once again,

the few photographs taken in this room. Twenty years later – see page 132 – London's Daily Express would do an

enhancement job on this picture, removing the central

Frank Browne thought it sub-standard and did not

include it in his album. It remains, however, one of

blotch and adding a figure to the right-hand table.

The luncheon menu-card for 14 April 1912, which Frank Browne acquired to illustrate his lectures (see chapter nine).

R M S TITANIC

CONSOMMÉ FERMIER

FILLETS OF BRILL EGG A L'ARGENTEUIL

CHICKEN A LA MARYLAND

CORNED BEEF, VEGETABLES, DUMPLINGS FROM THE GRILL.

GRILLED MUTTON CHOPS MASHED, FRIED & BAKED JACKET POTATOES

APPLE MERINGUE CUSTARD PUDDING

BUFFET. SALMON MAYONNAISE NORWEGIAN ANCHOVIES

PASTRY POTTED SHRIMPS PLAIN & SMOKED SARDINES Soused HERRINGS

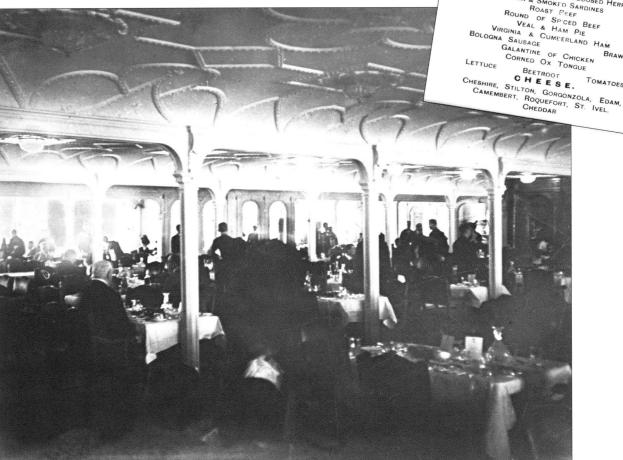

The Reading and Writing Room on A-deck of *Titanic*. Frank Browne did not consider the photograph good enough to include in his album, but it is interesting to compare it with the one on page 92.

The Reading and Writing Room on A-deck of *Olympic*. The windows of this room were eleven feet high. The bright band at the top of the windows is the portion of the room which rises above the level of the boatdeck, forming the still higher sun-deck that stood eighty-two feet above the water-line.

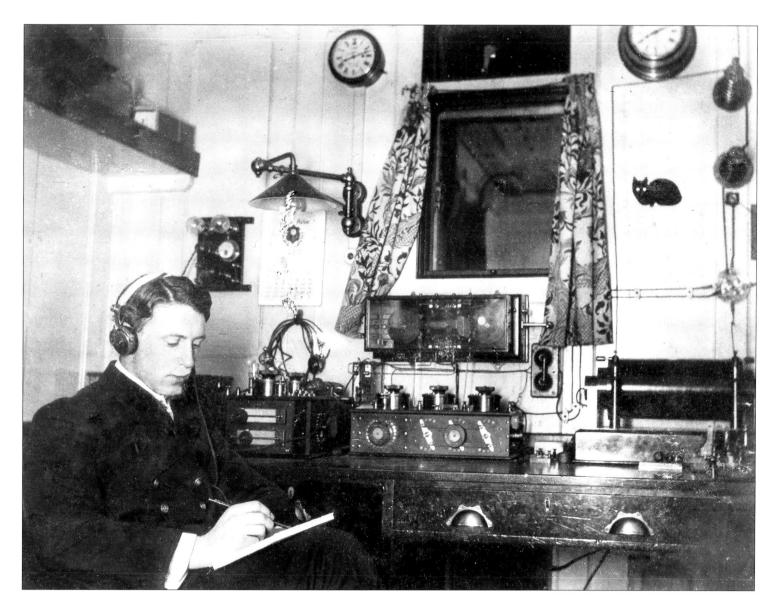

An excellent interior shot of the *Olympic's* Marconi room, showing Mr Brent at work. Compare with the recently corrected photograph from the *Titanic* shown on page 77. The telephone by which the operator could transmit messages to the bridge, about icebergs ahead or anything else, can be seen just to the right of the Marconi-man's head.

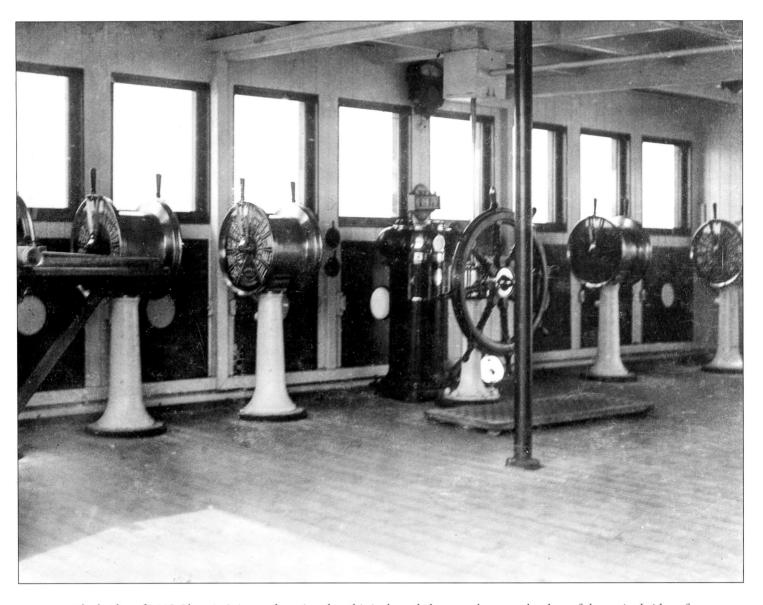

The bridge of RMS *Olympic*. It is worth noting that this is the only known photograph taken of the entire bridge of either *Olympic* or *Titanic*. Other photographs only show small portions of the *Olympic*'s bridge – which was practically identical to that of her sister ship. Film sets have been based on this photograph for accuracy.

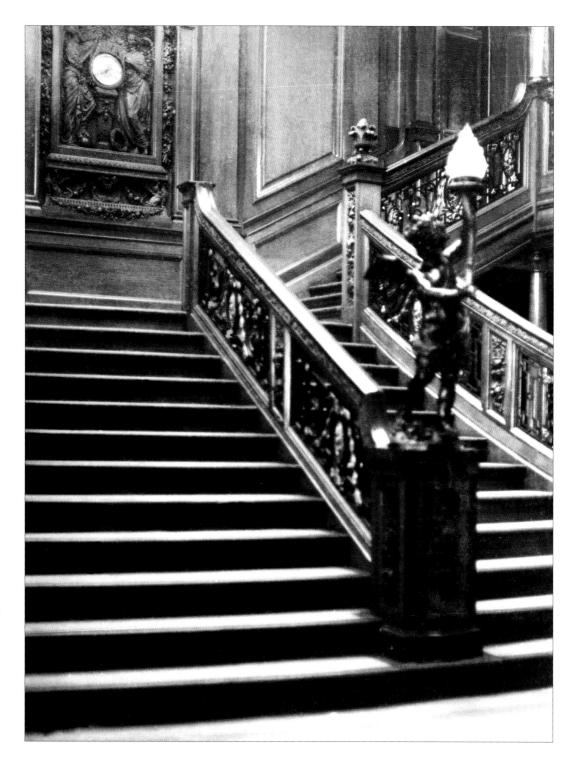

The Grand Staircase of the *Olympic*. There were seven flights of stairs similar to this, the topmost one. All the woodwork and carving is in pale oak. The carving on the back wall represents 'Honour and Glory crowning Time'.

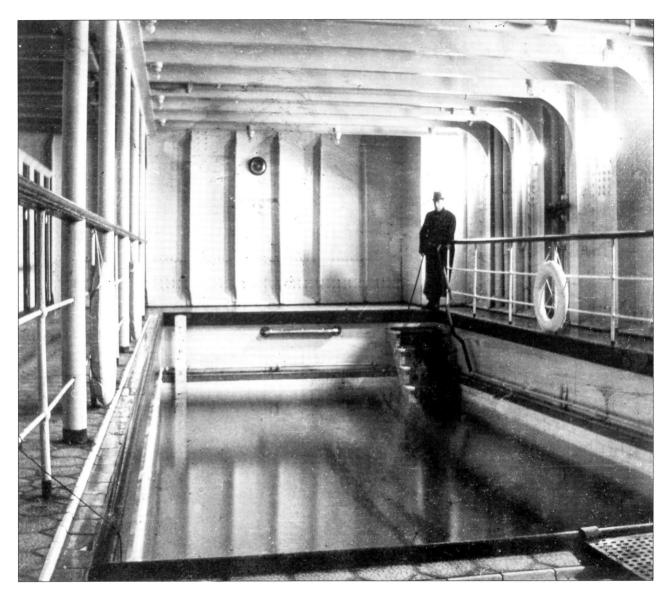

Swimming-bath of RMS *Olympic*, identical in every respect with that of the *Titanic*. See chapter six for Frank Browne's description of its dimensions. The gentleman at the rear looks like, and may be, Browne's brother, William, who came to meet the liner at Queenstown. Situated away down on F-deck, this bath adjoined the Turkish Baths and Electric Baths with their state-of-the-art steam-rooms, hot-rooms, temperature-rooms, cooling-rooms and shampooing-rooms. Frank Browne had a swim here early in the morning of 11 April 1912.

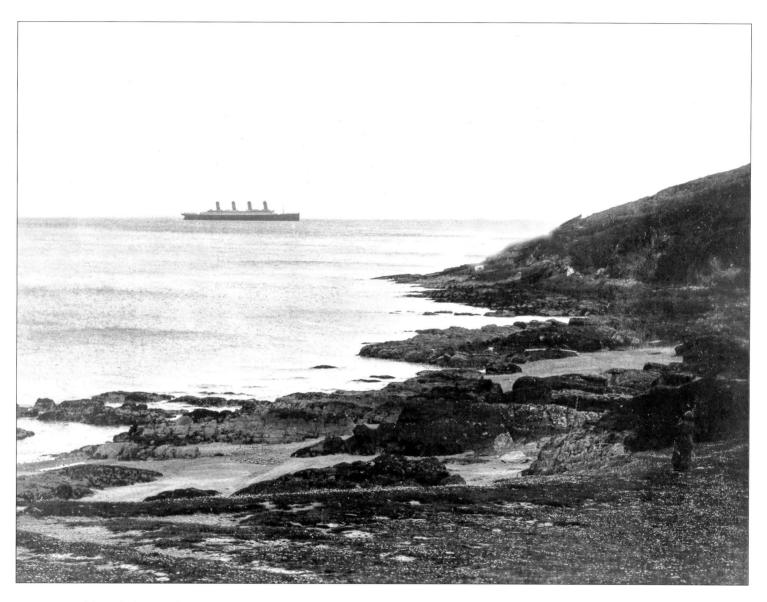

Although frequently stated to be the *Titanic*, this is in fact Frank Browne's last picture of RMS *Olympic* taken from Crosshaven, County Cork. It is included here as an effort to dispel a myth (see p. 101).

Chapter 6

Sailing Aboard the *Titanic*

When Browne was teaching at Belvedere College in Dublin in 1906, he founded a school journal that is still published today, *The Belvederian*. In 1912 he contributed an article to *The Belvederian* that described his own journey on the *Titanic* from Southampton to Queenstown. This article was reproduced for the first time in this book.

Browne used many of his own photographs to illustrate the article, but the first photograph he included was taken by Thomas Barker of *The Cork Examiner*. Since he was writing over a hundred years ago for the school-children of Belvedere, he makes several references that you may struggle to follow. I have included endnotes that explain these.

Interestingly, Browne chose to leave out possibly the most famous part of his time aboard the *Titanic*. Perhaps he did not want to tell the schoolboys of Belvedere of the 'only time holy obedience saved a man's life!'

The story goes that during his trip to Queenstown Browne was befriended by an American couple – millionaires – who were seated at the same table as him in the *Titanic's* first-class dining-room. The couple invited him down to the Marconi room (p. 77) and asked him to send a message to his superior (the Jesuit provincial) in Dublin. He was to ask for permission to stay for the remainder of the voyage to New York. The American couple would pay his way.

The message was sent and a reply was waiting for him when the *Titanic* reached Cork Harbour. It consisted of five words:

GET OFF THAT SHIP - PROVINCIAL.

By the time the *Titanic* had sunk, Browne was back at his theological studies in Dublin. His photo on page 77 is the only known photo of the Marconi room in existence.

Browne had also published an earlier account of his voyage in the *Cork Constitution* on 13 April 1912. This article was printed anonymously, but I have no doubt that it was authored by Browne. Both articles are reproduced in this book.

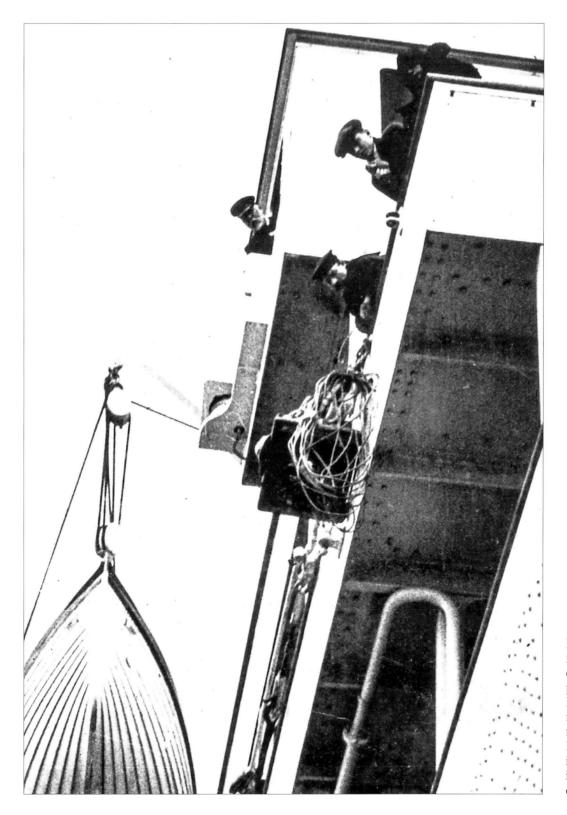

David Davison of Dublin made this enlargement of a section of the last photograph of Captain Edward Smith. Due to retire after the *Titanic's* return journey from New York, the captain is seen here gazing, ironically, into the emergency lifeboat.

At Sea on the *Titanic*

The Belvederian

he Southampton Town Clocks had just struck a quarter past twelve on April 9th¹ when the *Titanic* moved away from the Quay. So slowly and gently did she move that as I leaned over the water, I could hardly realise that we were actually in motion. With a feeling akin to suppressed excitement I watched the scene, for it was my first experience of actual travel on an ocean liner, and for a beginning I could not have 'struck' a bigger boat. To convey any idea of her size is difficult. Time and again these ships have been described by professional penmen, each one endeavouring to surpass his predecessors in the wealth and number of adjectives employed.

My first glimpse of the ship had been from the train as it slowly steamed through the streets and the docks of Southampton. At the station I was met by Tom Brownrigg, also an Old Belvederian.² Together we started; but it was not till, having ascended three flights of stairs, we stood on the little gangway that gave admission to the Saloon entrance lobby, that we could form any adequate idea of the size of the 'largest ship in the world'.

Left and right stretched a wall of steel that towered high above the roof of the station that we had just left. We were about forty feet above the quay level, and yet scarce more than half way up the side of the ship. Below us the people looked tiny, while some hundred and twenty yards aft we could see the Second-Class passengers crossing the gangway into their portion of the ship.

Once on board, a visit to the Purser's office, where a letter of introduction served as a passport to the genial friendship of Mr McElroy, sent us looking for Cabin A₃₇, which being translated meant Cabin ₃₇ on Deck A. For those who have no acquaintance with the internal economy of modern liners it may be interesting to note that in the Saloon and Second Class portions of the ship the various Decks or Stories are named A, B, C, and so on, beginning from the top downwards. On the *Titanic* the decks numbered in this way for the Saloon went from A (the promenade deck above which there were still the Boat and Sun Decks) to E Deck some five stories below. A general description of the arrangements may not be out of place, and will make after events more clear. On the Boat Deck (about 78 feet above the water or a little more than the height of Belvedere House)³ were situated the Gymnasium and the officers' quarters and Bridge. On A Deck were the principal public rooms: the Lounge, which was the finest room ever planned in a ship, with huge bay windows eleven feet high looking out on the promenade deck, the Writing and Reading Room,

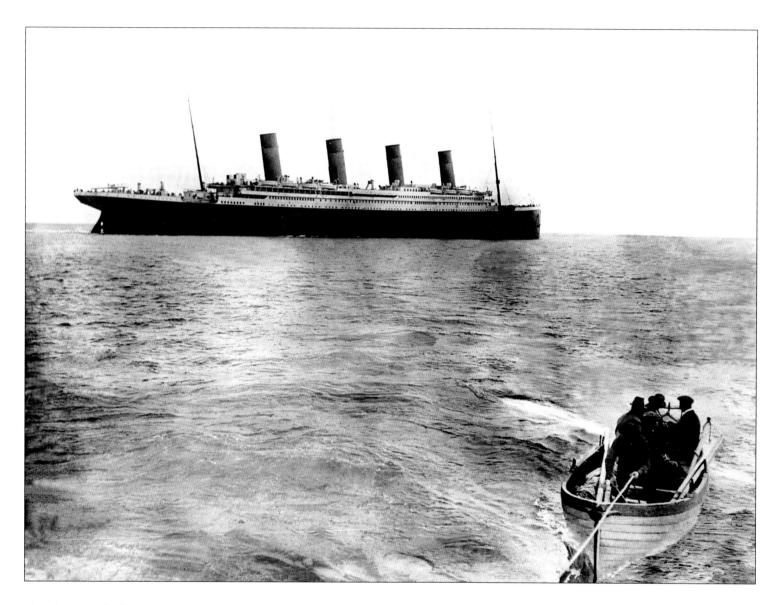

The photograph above is the very last one which Frank Browne took of the departing *Titanic* shortly after 1.55pm on 11 April 1912. Remember that he took this from the deck of the tender *America* with at least three other cameramen standing beside him.

mahogany inlaid with Mother of Pearl. In addition to these public rooms there were about forty staterooms, which, having large windows looking out on the promenade deck were considered among the best on the ship. On B Deck were all the great Suites of rooms which only millionaires could afford to engage. Here were apartments furnished in any style to suit the most exacting taste. Over the doors their names informed you what the style represented: 'Louis XVI", 'Modern', 'Dutch', etc. On C Deck was the great Dining Saloon with the magnificent Reception Room in which there was seating accommodation for nearly six hundred people without any crowding.

D Deck was devoted entirely to staterooms, while on E Deck were situated the Turkish Bath, Racquet Court, Swimming Bath (about half the size of Tara Street Baths)⁴, and more staterooms. All these Decks were connected by broad handsome flights of stairs, and by a regular service of lifts.

Having glanced over this short description, the reader will understand the true significance of the title chosen for this account. Though still

and the great Smoking Room, the walls of which were made of polished

Having glanced over this short description, the reader will understand the true significance of the title chosen for this account. Though still beside the Quay, Tom Brownrigg and I were really 'at sea' as we searched for Cabin A₃₇, and even a steward to whom we applied for guidance could only say, 'That's somewhere aft, Sir'. Eventually we found the cabin, which proved to be a large and very prettily furnished bedroom, with a small private entrance hall and a large bathroom attached. Having left there my impedimenta we started to explore the ship as far as time would allow, before the Bugle sounded 'Visitors ashore'. Of course there was no reason for me to hurry, but for Tom the time came all too soon. As the best view was to be obtained from the Boat Deck, I took myself thither as soon as I had said goodbye to Tom. Looking over the side I saw moored close below us three liners, each of which in its day had been the greatest ship in the world. Nearest to us was the St Louis, next to her the Philadelphia (once the City of Paris), and beyond her the Majestic. How small they looked, and how out of date beside the *Titanic!*

A straining of the tugs attached to the bow and stern of the *Titanic* warned me that we were moving, and crossing to the other side I saw the Quay with its thousands of cheering people gradually dropping astern. Not one of that gay number dreamt that it was their last look at the *Titanic*, and at the friends she bore.

Scarce four hundred yards down the jetties were moored two other great liners, the *Oceanic*, and the *New York*. The *New York*, being on the outside,

was thronged with sightseers eager to cheer the great ship on her maiden trip. We on the *Titanic* crowded the sides to return their salutes. Suddenly there was a crack, a stampede of the sightseers on the New York, four more cracks like pistol shots in quick succession, and the great 10,000-ton liner, her steel cables having snapped like thread, drifted from her moorings drawn out into the Fairway by the wash of the Titanic. Bells clanged from the bridge of the Titanic, and far away aft the churning of the propellers ceased, but on came the helpless New York. Tugs blew their sirens and rushed to her aid, but on she came. A voice beside me said, 'Now for a crash', and I snapped my shutter. Then we rushed aft along the deck to see what would happen, only to see the black hull of the New York glide gently past, out into the open space where a few seconds before had been the stern of the *Titanic*. Soon the tugs drew in the broken cables, and the *New York* was towed slowly past us. Even then, however, she was not out of the way, for when the *Titanic* reversed her engines, to give a little more room, once more the New York was drawn across our bows. It was but for a moment, and then we slowly forged ahead down Southampton Water with the channel open and free before us. A tug came to take ashore the workmen and navvies who had been arranging the luggage in the storerooms, and we were fully off.

Luncheon followed soon, but it was a brief meal, everyone being anxious to be on deck while we steamed down the channel between England and the Isle of Wight. Here another indication of the size of our ship was given us. Following us down the narrow waterway came the RMPS *Tagus*, on her way to the West Indies. She was a boat of the smaller class, and reaching the point opposite Cowes where the Eastern channel separates from the Western, she took the course towards the setting sun, a thing that would have been impossible for us, for that channel, though the most direct for ships going southward to the French Coast, as we were, would have been too shallow for the *Titanic*, and consequently we steamed east towards Portsmouth and Ryde, passing on the way many indications of the dreadnought policy, in the shape of lines of 'scrapped' warships lying useless in the roads at Spithead.

'Could you tell me, Sir, why is the channel so narrow here?' The voice, a loud penetrating one that had not learned its intonation on this side of 'the Herring Pond', came from above me, and I looked up to see whence it proceeded. Its owner was well dressed, and from his appearance of some importance. 'Could you tell me, Sir, why is the channel so narrow here?' he repeated, and I thinking that he referred to the narrow distance between

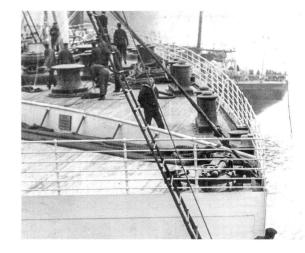

Browne is on the starboard bow of A-deck. In the distance the stern of the liner *New York* has swung out in front of the *Titanic*.

Jacques Futrelle

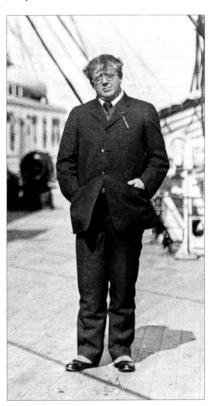

two chess-board forts that guarded the entrance to Spithead answered, 'I suppose when they built these forts they never calculated on having ships as big as the *Titanic*'.

'Oh, I did not mean that. Why is the land so near here?'

'Well, I suppose, Sir, that they could not shift the Isle of Wight back any further than it is.'

'How far would you say it is from shore to shore here, Sir?'

'I looked across and hazarded the answer. 'I should say about ten or twelve miles.'

'Well, how far is it from Dover to Calais?'

'Twenty-one.'

'Why then don't you English cross here?'

A great light dawned on me, and a ghost of a geography lesson in Syntax II⁷ classroom seemed to smile upon me from out of the past as I replied: 'Oh that's not France, that's the Isle of Wight.'

'I see. I thought it was France', and he moved off. I afterwards photographed him as he stood outside the Gymnasium. [He was Jacques Futrelle, the author.]

And so the afternoon wore on as we steamed down the busy channel watching the big four-masted sailing ships, and the cross-channel packets tossing in the choppy sea, while on the *Titanic* there was no indication that the ship was at sea save the brisk cool breeze blowing along the decks, and the swiftly moving panorama of distant coast line.

Owing to the delay caused in starting by the *New York* incident, we did not arrive at Cherbourg till evening was well advanced and while we were saying good-bye to those to whom the excitement of the morning had served as an introduction, and who were getting off at Cherbourg, the bugle sounded the Dinner Call. That I was not the only person 'at sea' on the *Titanic* was proved by the requests made me by some who could not find their way to the Dining Room!

As we sat down to dinner – we were eight at our table – we could see the newly arrived passengers passing in the lobby outside and occasionally hear the busy hum of work as the luggage and mails were brought on board. But soon it all quietened down and after a time someone remarked, 'I wonder have we started yet.' We all stopped for a moment and listened, but noticing no vibration or noise the answer came, 'No, we can't have started yet.' But the waiting steward leant over and said, 'We have been outside the breakwater for more than ten minutes, Sir.' So gentle was the

motion of the ship that none could notice its movement (and there was no drink on the table stronger than Apollinaris!!).⁸

After dinner we listened to that orchestra, which in a few days was to win a place in history more tragically glorious than that held by many others of the tragedy of April 15th. But none of us thought of these things then. Those of the passengers who were early astir next morning, and they were many, for the first night at sea is generally a restless one, even when soothed by all the comfort and luxury of a *Titanic*, witnessed the curious evolutions of the liner as she turned and twisted on a serpentine path while steaming north from the Lizard to Queenstown. It was merely to test the compasses that she did so, and it is a common practice on the ocean-going ships when far from land and not pressed for time.

Then as the day grew older out from the northern horizon the blue haze took a more substantial form and I knew that my brief voyage was drawing to its close.

As we passed Daunt's Rock and slowed up to take the pilot on board from his little tiny boat, someone asked 'What fort is that?'

'Templebreedy, one of the strongest in the kingdom.'

'And do Redmond and his Gang want to take that place?'

'Why do you call them a "Gang," Sir?' was the answer from another. At that moment the Halls at Westminster were filling for the first reading of the Home Rule Bill!⁹

Then came the tender and the mails and soon the hour of leaving came for me. As I passed down the gangway I met Mr McElroy and Mr Nicholson, Head of the Mail Department of the *Titanic*.

'Goodbye,' I said, 'I will give you copies of my photos when you come again. Pleasant voyage.'

And so they went. They never came back, one dying at his post far down in the heart of the ship as he strove to save the more precious portion of his charge, the other calmly facing death as he strove to reassure the terror-stricken, and to render up the jewels given to his keeping.

Four days passed and then came the awful news, whispered at first, then contradicted, but finally shouted aloud in all its horror of detail by the myriad-throated press.

And here in Ireland, in Queenstown, we did not forget those whom we had seen departing in all the joy of hope and confidence, for we gathered in the great Cathedral to pray for those who had departed, and for those on whom the hand of sorrow had fallen so heavily.

NOTES

- 1. Actually, it was 10 April 1912.
- Belvedere College is a Jesuit school in Dublin, alma mater of Frank Browne S and James Joyce.
- The Community House at Belvedere College. This five-storey building, completed for Lord Belvedere in 1785, is over seventy-five feet high.
- 4. Dublin swimming pool measuring twenty-two yards long and twelve yards wide.
- 5. A Portuguese Mail Ship.
- 6. The first HMS *Dreadnought* was named and launched by Queen Elizabeth 1 in 1573. The ninth Royal Navy ship of that name was launched in 1906 and gave its name to subsequent battleships of every nation. By the time Churchill came to the Admiralty in 1911, eighteen British dreadnoughts had been launched. In the 1912 Naval Estimates he sought money for a further five.
- Syntax II is the name of a college year at Belvedere. It corresponds to third-year in High School.
- Apollinaris Water is a mineral water from the eponymous spring in the Ahr valley of Germany.
- 9. The Home Rule Bill of 1912 was the issue that dominated Westminster parliament and the European newspapers in April 1912. If passed it would grant Ireland 'home rule', devolving some powers from Westminster to Dublin. It was the third such bill (the first was introduced in 1886, the second 1893). It was passed, but would never be implemented due to the outbreak of the First World War, the Easter Rising of 1916, and the subsequent declaration of the first Dáil in 1919.

A Saloon Passenger's Impressions

Cork Constitution

ook how that ship is rolling, I never thought it was so rough.'
The voice was a lady's, and the place was the sun deck of the *Titanic*. We had just got well clear of the eastern end of the Isle of
Wight, and were shaping our course down the English Channel towards
Cherbourg.

The ship that had elicited the remark was a large three-masted sailing vessel, which rolled and pitched so heavily that over her bows the seas were constantly breaking. But up where we were – some 6oft above the water line – there was no indication of the strength of the tossing swell below. This indeed, is the one great impression I received from my first trip in the *Titanic* – and everyone with whom I spoke shared it – her wonderful steadiness. Were it not for the brisk breeze blowing along the decks, one would have scarcely imagined that every hour found us some twenty knots further upon our course. And then this morning, when the full Atlantic swell came upon our port side, so stately and measured was the roll of the mighty ship that one needed to compare the movement of the side with the steady line of the clear horizon.

After a windy night on the Irish Sea, when the sturdy packet boat tossed and tumbled to her heart's content – by the way, have ships a heart? – the lordly contempt of the *Titanic* for anything less then a hurricane seemed most marvellous and comforting.

But other things besides her steadiness filled us with wonder. Deck over deck and apartment after apartment lent their deceitful aid to persuade us that instead of being on the sea we were still on *terra firma*.

It is useless for me to attempt a description of the wonders of the saloon – the smoking room with its inlaid mother-of-pearl, the lounge with its green velvet and dull polished oak, the reading room with its marble fireplace and deep soft chairs and rich carpet of old rose hue – all these things have been told over and over again and only lose in the telling. So vast was it all that after several hours on board some of us were still uncertain of our way about, though we must state that, with commendable alacrity and accuracy, some 325 found their way to the great dining room at 7.32, when the bugle sounded the call to dinner. After dinner, as we sat in the beautiful lounge listening to the White Star orchestra playing the 'Tales of Hoffmann' and 'Cavalleria Rusticana' selection, more than once we heard the remark, 'You would never imagine you were on a ship.' Still harder was it to believe that up on the top deck it was blowing a gale, but we had to go to bed, and this reminds me that on

the *Titanic* the expression is literally accurate. Nowhere were the berths of other days seen, and everywhere comfortable oaken bedsteads gave place to furniture in the famous suites beloved by millionaires. Then the morning plunge in the great swimming bath, where the ceaseless ripple of the tepid sea water was almost the only indication that somewhere in the distance 72,000 horses in the guise of steam engines fretted and strained under the skilful guidance of the engineers, and after the plunge a half-hour in the gymnasium helped to send one's blood coursing freely, and created a big appetite for the morning meal.

But if the saloon of the *Titanic* is wonderful, no less so is the second class, and in its degree the third class. A word from the genial purser acted as the 'Open Sesame' of the Arabian Nights, and secured us an English officer and his son, whose acquaintance I had made at lunch, and a free passage through all the floating wonder. Lifts and lounges and libraries are not generally associated in the public mind with second-class accommodation, yet in the *Titanic* all are found. It needed the assurance of our guide that we had left the saloon and were really in second class.

On the crowded third class deck were hundreds of English, Dutch, Italian and French mingling in happy fellowship, and when we wandered down among them we found that for them too the *Titanic* was a wonder. No more general cabins, but hundreds of comfortable rooms, with two, four, or six berths, each beautifully covered in red and white coverlets. Here too are lounges and smoking rooms, less magnificent than those amidships to be sure, but none the less comfortable, and which, with the swivel chairs and separate tables in the dining rooms, struck me as not quite fitting in with my previous notion of steerage accommodation.

Chapter 7

The *Titanic*Arrives at Queenstown

At II.55am on Thursday, II April, the *Titanic* reached Cork Harbour in the south of Ireland. The following day's local newspaper, *The Cork Examiner*, described her arrival as follows:

As one saw her steaming slowly, a majestic monster floating it seemed irresistibly, into the harbour, a strange sense of might and power pervaded the scene. She embodies the latest triumphs in mercantile engineering and although a sister ship of the *Olympic* is an improvement in many respects on the latter.

Whatever conditions the modern voyager looks for in a vessel which he selects to bear him safely over the ocean's vast bosom he will find here with the acme of perfection.

Approaching the Irish coast, the *Titanic* flew its red and white signal flag – the colours vertical to signify the letter, G – to convey the captain's message: 'I want a pilot.' Not far from the Daunt lightship, off Roche's Point, the pilot came on board. The special pilot for the *Titanic* was John Cotter, aged fifty-seven.

I spoke to a friend of his, David Aherne, Cobh's eldest surviving pilot at the time, about what would have been involved.

Twelve hours before the estimated time of arrival, John Cotter would have left Queenstown to take up his position in the pilots' signal tower above Roche's Point lighthouse. On sighting the *Titanic* through the telescope he would have ordered his four-man pilot's boat, a former whaler, to be put to sea. The oarsmen would have rowed between one-and-a-half and two miles to meet the liner, which by then would have slowed to rowing speed. The front oarsman would have grabbed a rope thrown over the liner's side, allowing the pilot time to jump on to the rope-ladder (known as the Jacob's Ladder), which had been lowered for his arrival.

John Cotter went straight to the bridge and stood beside Captain Edward Smith who was 'in charge of the vessel at all times'. Using his local knowledge, the pilot would have instructed the Captain to follow a straight line-of-sight between the centre of the harbour's mouth and Bennett's Court, a prominent landmark on Great Island in the harbour. A terrace of coastguard houses stood on the mainland to the rear of Roche's Point.

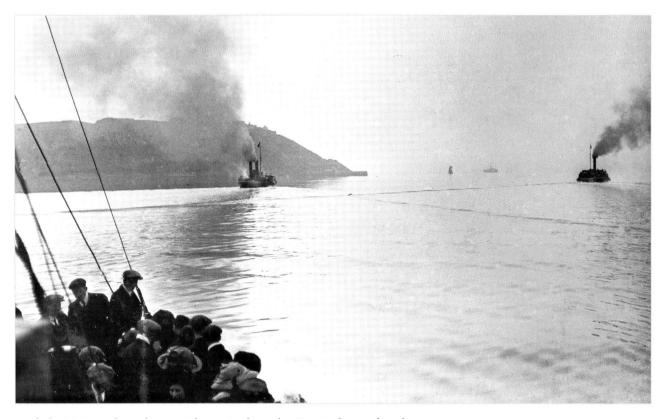

Roche's Point, Cork Harbour, at the spot where the *Titanic* dropped anchor.

As soon as the first of these came into view, Mr Cotter would have told Edward Smith to drop anchor because this was the spot where the *Titanic* would have 1000 yards of leeway in any direction.

As soon as the *Titanic* came to a standstill, the two tenders, *Ireland* and *America*, came alongside, one carrying passengers and mail, the other bringing press reporters and photographers as well as some guests, including Frank's brother, Rev. William Browne.

While Frank Browne was getting his belongings together and taking a few last photographs, three first-class passengers, seven second-class passengers and one hundred and thirteen steerage passengers came aboard. Recent books have stated that no first-class passengers boarded at Queenstown. Three did. They were Miss Daisy Minahan of Green Bay, Wisconsin, and her parents Dr and Mrs William Minahan of Fond du Lac,

Wisconsin. The two women would survive. The total number that sailed from Queenstown, however, is still disputed due to confusion over (a) names being misrecorded, (b) duplications, (c) stowaways, (d) crewmen absconding.

Mr Thomas Barker, *The Cork Examiner* photographer, knew Frank Browne well, and it is likely that they met on board and took pictures together. The Odell family, who were disembarking at Queenstown, continued to photograph one another on the deck of the tender.

The Cork Examiner reporter who climbed on board was overwhelmed with the beauty of the *Titanic* and in the following day's newspaper devoted two full columns to describing the magnificence of its appointments. Following this, he turned to the question of safety:

Safety is the first consideration with all voyagers and no excellence can compensate for lack of it. *Titanic* is the last word in this respect, double bottom and watertight compartments, steel decks, massive steel plates all in their way making for security, safety and strength. Nothing is left to chance: every mechanical device that could be conceived has been employed to further secure immunity from risk either by sinking or by fire. Should disaster overtake her through contact with rock, instant means can be taken to avert the consequences by concentrating attention on the compartment damaged, which is instantaneously ascertained by an indicator in view of the officer in charge of the bridge who is enabled at the same time by the moving of a lever to close up and seal all or any of the watertight compartments into which the ship is divided. The dangers of the sea, therefore, are practically non-existent on this latest magnificent vessel.

Through the courtesy of Messrs J. W. Scott & Co., the local agents, a number of Pressmen and others were yesterday shown through the *Titanic* and the arrangements made for the transfer of the mails and passengers in the hand of the firm were of their usual satisfactory character.

The *Titanic* weighed anchor at 1.55pm and proceeded on her first western journey. To the battle of the transatlantic passenger

The photograph here, taken on the boat deck of the *Titanic* while at anchor in Cork Harbour, was sent by Father Browne to the *Daily Express* in 1932 (p. 132), so one presumes that he took it himself. He may have been standing beside his friend, Thomas Barker (*The Cork Examiner* photographer) who took similar pictures on the boat deck.

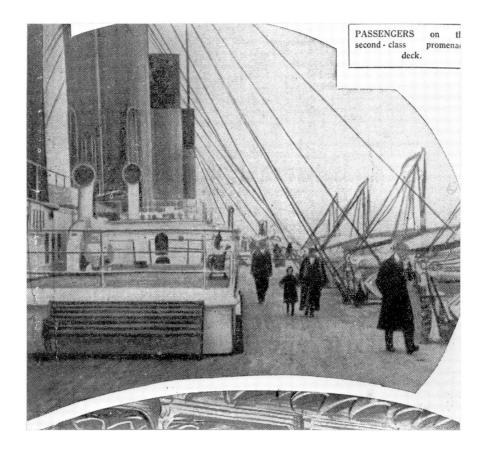

service, the *Titanic* adds a new and important factor of value to the aristocracy and plutocracy attracted from East to West and from West to East. With the *Mauretania* and *Lusitania* of Cunard, the *Olympic* and *Titanic* of the White Star, and *Imperator* and *Kronprinzessin Cecilie* of the Hamburg-Amerika, in the fight during the coming season, there will be a scent of battle all the way from New York to the shores of this country: a contest of sea giants in which the *Titanic* will doubtless take high honours.

At 1.55pm the liner weighed anchor and the disembarked passengers on the tender, Browne among them, waved goodbye. On moving away the *Titanic* gave the customary three long blasts on her siren to which the tender's hooter replied at similar length. Then the liner gave a final very short blast that was answered in like manner: a single note to bid a final farewell to the ship's company. For most of them it would be very final.

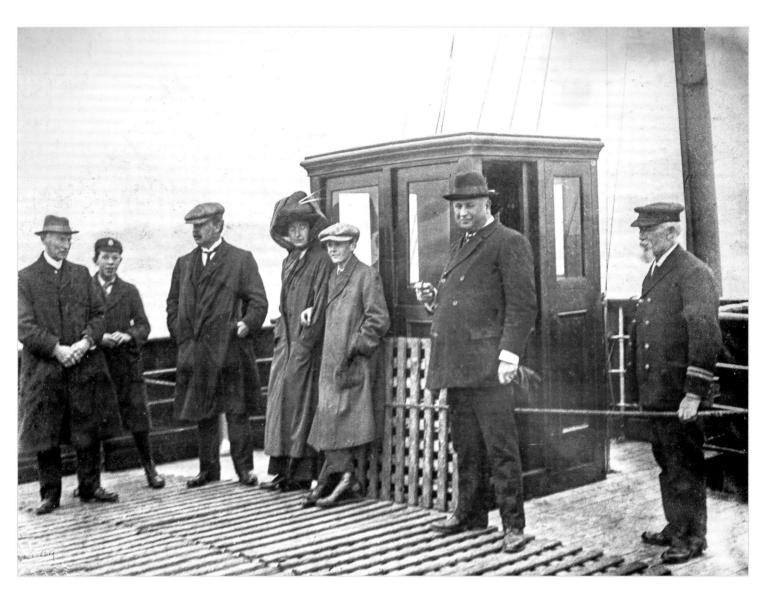

The Odell family on board the tender *Ireland* after they had disembarked from the *Titanic* with Frank Browne. Young Jack Odell – in school cap – is accompanied by his mother (in lee of wheelhouse). Captain McVeigh stands on the right.

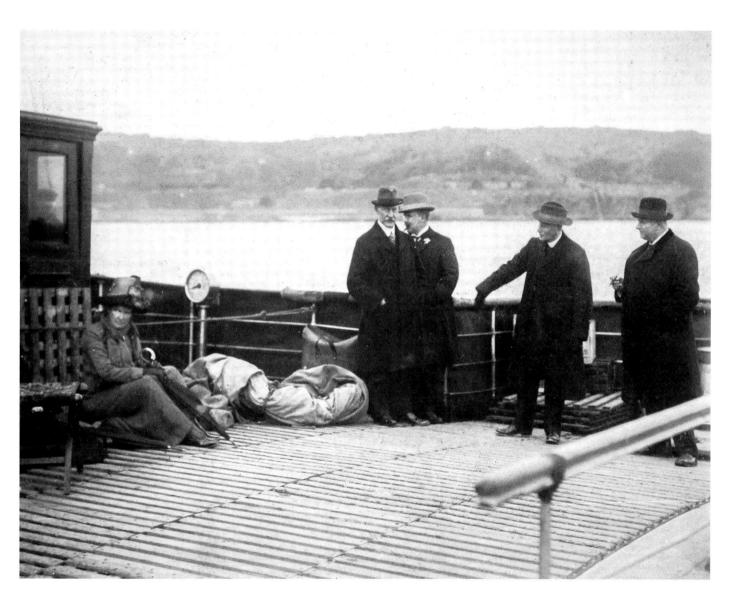

Another shot on the tender *Ireland* in Cork Harbour, showing the writer, R. W. May (centre), standing behind his brother, Stanley May.

Chapter 8

The *Titanic* Sinks

EXCESSIVE SPEED.

What the Californian Might Have Done.

Lord Mersey yesterday delivered the judgment of the Court that inquired into the loss of the

Many ladies went to the Scottish Hall, Buckingham Gate, to hear the judgment read, among them an elderly woman in mourning, her hat

Lord Merey found that the disaster was due to collision with an iceberg brought about by the excessive speed at which the saip was being savigated. Captain Smith made a very grivous mitakoi in not reducing speed at night when be reached the region where ice might be expected but in view of the fact that it had not been the practice of liners to reduce speed as long as the weather was clear he was not guilty of aggligence.

It was to be hoped that the last had been heard of the practice of geing at full speed at night in an ice region—a practice due probably to competition and the desire of the public for oright passages.

It was irregular for Captain Smith to give Mr. Ismay the Baltic's ice message and improper for Mr. Ismay to retain it, but that incident had

no mintenee on margason:

Lard Mersey did not believe that the presence
of Mr. Lunay on board induced Captain Smith
to neglect presautions that he would otherwise
have taken. Captain Smith was not trying to
make a record passage, or, indeed, an exceptionally quick passage. He was not trying to
please anyledy, but was exercising his own dis-

SIR COSMO DUFF GORDON.

The ladies took a keen interest in that part of the judgment dealing with Sir Cosmo Duff-Gordon. It will be remembered that the calling of Sir Cosmo and Lady Duff-Gordon as witnesses attracted large numbers of women to the inquiry. Lord Mersey found that the gross charge made against large made ag

Ismay's position as managing director of the con pany imposed on him a moral duty to wait to beard until the ship rank. If he had not jumpe into the beat another life would have been lost. As for the Californian, the Court's finding we had when she first care the collected the California when the first care the collected the California waits return any serious role and so have one to the assistance of the Titane. Had the don

A good and proper look-out for ice was no kept. An extra look-out should have been place on the stem-head and a sharp look-out from both

The organisation on the ship should have been better, and, if it had been, it was possible that more lives would have been saved.

nore lives would have been saved.

Some of the boats failed to attempt to savlife when they might have done so. This wa
particularly the case with No. 1 beat.

BOARD OF TRADE.

The omission by the Board of Trade during somany years to revise the rules of 1894 was blame able.

There was no ground for believing that thric class passengers had been unfairly treated. In regard to the conduct of the boats after the Titanic sank Lord Merseys and that some, at a which we have the conductive the second of the conductive the when they wight have some so, and might have done so uncertuilly. This was particularly the case with boat No. 1 (the boat in which were the DHG Gordons). Solipett to these few adverse complete the property of the conductive the conductive three descriptions and the conductive three descriptions are considered to the conductive three descriptions are described by the conductive three descriptions are described by the conductive three descriptions are described by the conductive three described by the con

AS 107 No. 1 food to did not believe that it men were decreted from making the attempt be any act of Six Cosmo Duff-Gordon's. At the sam time be thought that it Six Cosmo had encourage the men to return to the position where the Titain lad foundered they would probably have made at effort to do so, and could have saved some lives.

RECOMMENDATIONS.

should be based on the number of persons intende should be based on the ship and not on the tonnage. The Board of Trade's inspection of boats shoul be more searching than littlesto. More care should be taken in the manning of

Every look-our man should undergo a sight test. There should be organised a police system to secure obetise to orders and proper control and guidance in time of emergency.

Steps should be taken to call an international

Steps should be taken to call an international conference to consider a common line of conduct in respect of the working of shipe, the provision and working of the saving appliances, the installation of wireless telegraphy and the method of working at the reduction of speed or alteration of course in the reduction of c. and the use of searchights.

The *Titanic* sank at 2:20am on the morning of 15 April 1912. Back in Dublin, Frank Browne's initial reaction to the news was one of relief. As in Montreal, New York and Boston, the Dublin evening newspapers carried a very inaccurate version of the story. The headlines in *The Evening Telegraph* ran:

Terrible Disaster in Mid-Atlantic

Ill-fated Maiden Voyage Collision with an Iceberg

Women Taken Off by Lifeboats

All the Passengers Saved *Titanic* on Her Way to Halifax

The smaller print in that newspaper reported on the reaction to this news at Dublin Port.

Dublin shipping, which acts as a very generous 'feeder' to the transatlantic liners, was deeply concerned today as to the possible safety of the *Titanic*. Newspapers were grabbed on sight. Telephones and telegraphs were kept busy as each firm concerned begged for the latest intelligence regarding the catastrophe. The possibilities of a rescue formed the sole topic of conversation at Dublin Port today.

Browne would have been more reassured by next morning's Dublin newspapers. *The Irish Times*, for example, read:

The Lost Titanic

Titanic Sunk

Disaster To Liner On Maiden Voyage Struck An Iceberg

The *Titanic* was so seriously damaged that the passengers – over 1470 in number – were at once transferred to the *Parisian* and the *Carpathia*. Fortunately the sea was calm and the operation was safely completed early yesterday morning.

The *Virginian* then took the liner in tow and attempted to get her to Halifax or to the beach near Cape Race. The liner, however, had been too severely damaged to keep afloat and she sank at 2.20 (American Time) yesterday morning.

Following a transcript of the brief Reuter's telegram which simply said: 'New York: the *Titanic* sank at 2.20 this morning', all Dublin newspapers carried the following bulletin.

The following statement has been given out by White Star officials: Captain Haddock of the Olympic sends a wireless message that the Titanic sank at 2.20 this morning after passengers and crew had been lowered into lifeboats and transferred to the Virginian.

All the newspapers, in Ireland as in England, were happy to announce that at Godalming, Surrey, the father of Titanic's Marconi operator, Jack Phillips (p. 78), had received the following message from his son.

> 'Making slowly for Halifax. Practically unsinkable. Don't worry.'

On 16 April, *The Irish Times* was still reassuring:

News Creates Sensation At Queenstown

143* Irish Passengers On Board

The first report circulated, stating that the Titanic had foundered as the result of a collision with an iceberg, caused consternation here in Queenstown as 143 passengers had embarked at this port.

The agents of the White Star Company, Messrs Scott & Co., were happily in a position to reply that the passengers were all safely transferred to the Virginian.

*In fact 123 passengers embarked at Queenstown, three in first class, seven in second class and 113 in third class.

It was not until the following day, Wednesday, 17 April, that Frank Browne, along with the rest of Ireland, learned the true story. The headlines of *The* Irish Times made heart-breaking reading. Among the pages of coverage, the reader learned that:

Working Wireless at 2,000

Miles

London, Wednesday.

The Select Committee of the House of Albert Spicer, that his company from San Francisco to was distant 2,400 miles. ers ago they were told that the Marcon were coming and

ne at San Francisco and the other at nine days. On the sixtieth

SAN FRANCISCO TO HONOLULU, now did work with some of the leading firms in San Francisco. These firms had

between San Francisco and Chicago by day, ongest direct distance being 1,150 miles Ie understood that there now was a Poul-en company being formed in London, and

THEY SPOKE TO A SHIP IN THE NORTH ATLANTIC 8,000 MILES AWAY, nd yet four days afterwards they could not get into touch at a distance of a few undred miles. "That callimed Mr. Thompson," "That convinced me, ing else that we were on the right track it don't ask me to say that we have go thing that will de certain things unti-re have the equipment. It takes a little ime to put in an installation."

Mr. Faber-How long? rtain things u

ago they were told that the Ma

ne at San Francisco and the other at

TRANSMITTED 3,000 WORDS FROM SAN FRANCISCO TO HONOLULU, nd when in a week afterwards they were 'tuned up" they worked regularly. They rms in San Franci

He understood that there now sen company being formed in London, and don were interested in on to say that one particular night

THEY SPOKE TO A SHIP IN THE NORTH ATLANTIC 8,000 MILES AWAY and yet four days afterwards they t get into touch at a distance of claimed Mr. Thompson, "more than any thing else that we were on the right track it don't ask me to say that we have got thing that will do certain things until we have the equipment. It takes a little ime to put in an installation." Mr. Faber-How long?

Mr. Faner-thw mog.

Mr. Redmond-While vent belief in the possibilition are not prepared to one proved?—It has bee stend that I would be wanney in it, take all the distance of the result of the resul

Larges.

The departure yesterday of the newest ocean giant, the White Star Line, was an event that m the last note of progress in modern shipbuilding. Nominally of the same size as her sister ship, the Olympic, 45,000 tons, she proves, upon final measurements, to be about a thousand tons bigger, this being in consequence of some three inches extra in length. oupled with technical considerations which are taken into account by those upon whom the duty rests of officially determining the tonnage of the modern steamship. To the Titanic, therefore, belongs the honour of being absolutely the largest vessel afloat. builders and shipowners alike are constantly learning from experience. The Olympic, it was found from observation, gave suggestions of even further developments in the all important direction nowadays of increased luxury for passengers, and these have been embodied in the Titanic. They take the form chiefly of an elaboration of dining facilities in the way of cases and reception rooms, adjuncts to the great dining saloon, and of two elaborate suites of private apartments—parlours, bedrooms, and bathrooms-to each of which is provided a private out-door promenade, decorated in a style of half-timbered walls of the Elizabethan period. For this latest extension of luxury which further helps to transform the Titanic into a palace of delight, a high price is naturally demanded. what is £850 to an American millionaire? All the magnificent decoration of the Olympic has been repeated, as well as the luxurious Turkish baths, swimming bath, gymnasium, replete with the latest massage machines, and squash racquets courts. In a humbler degree the second and third-class accommodation is quite of the finest imaginable. The Titanic has a passenger list of 325 first, 300 second. and 750 third class, her total capacity being 725 first, 650 second, and 1,200 third. Among the passengers was Mr. Bruce Ismay and a number of well-known Americans. A large concourse of people had gathered to speed the vessel on her maiden voyage, and she made an impressive picture as she quietly glided, in brilliant sunshine, down Southampton water, quite dwarfing all adjacent shipping.

There is now, unhappily, no doubt that the disaster to the *Titanic* is one of the most appalling catastrophes in maritime history. It would appear that the number who perished reaches the awful figure of 1490. [In fact over 1500 people lost their lives.] The terrible calamity has caused the greatest consternation throughout the world.

St John's, Newfoundland, Tuesday: All hope of any passengers or members of the crew of the *Titanic*, other than those on board the *Carpathia*, being alive has now been abandoned and this afternoon all steamers which had been cruising in the vicinity of the disaster continued their voyages.

Queenstown, Tuesday: It would be impossible to describe the dismay with which news of the terrible catastrophe to the *Titanic* and her freight of human souls was received here this morning.

People arrived here this afternoon from various parts of the country and it was distressing to see the great anxiety with which they endeavoured to get news of some helpful kind from the White Star offices.

On the same day, the Dublin *Evening Telegraph* unravelled the mystery of that telegram from Jack Phillips.

Mistake About A Message

The Press Association, Godalming correspondent, telegraphs: The message stated to have been received last night by Mr & Mrs Phillips from their son, the wireless operator aboard the *Titanic*, turns out not to have been from him at all, but from another son in London. On receiving the message the father came to the conclusion that it was from his son on the *Titanic*, but this morning he stated that he must have been mistaken.

Browne must have been shattered to read this news because he had chatted with Jack Phillips at least twice. They had met on board the *Adriatic* as well as in the Marconi room of the *Titanic*.

Browne kept no record of his photographic sales at the time, but we

know that his pictures appeared in newspapers across the globe, a British 'exclusive' being given to London's *Daily Sketch*.

On 19 April he travelled from Dublin to Queenstown where he photographed the town in mourning and showed the White Star flag at half-staff. The Cunard flag was similarly flying in sympathy.

On 22 April he attended Requiem Mass at St Colman's Cathedral, Queenstown. Bishop Robert Browne officiated and the cathedral was packed to capacity.

In the light of the terrible catastrophe every little memento of the *Titanic* became precious. The card given to him by the liner's physical education officer (p. 71), for example, acquired a tragic character when Browne learned that the friendly gymnast had lost his life.

The passengers who had disembarked together at Queenstown began to correspond with one another. Frank kept the letters he was sent at this time as well as the *Titanic* menu card (p. 90), which somebody conveyed to him by post. It was assigned to an envelope marked 'Very Important'.

No. 970.—THURSDAY, APRIL 18, 1912.

THE PREMIER PICTURE PAPER [Registered as a Newspaper.] ONE HALFPENNY,

FIRST UNCLOUDED HOURS OF TITANIC'S FATAL VOYAGE.

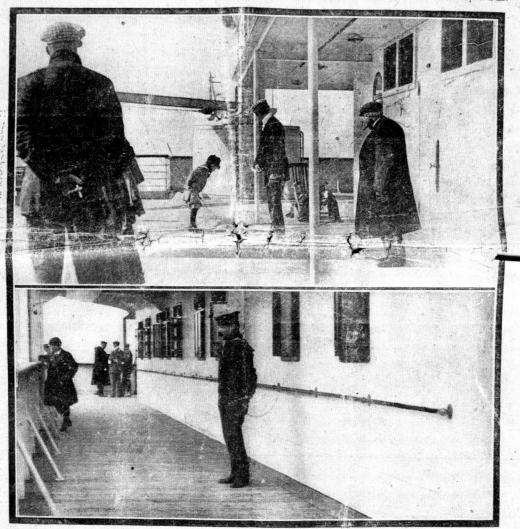

Facing and above: Two photographs which Father Browne took of London's *Daily Sketch*, 18 April 1912. His handwritten note on the facing photograph is explained in chapter nine.

THE VOYAGE OF DISASTER: EXCLUSIVE PHOTOGRAPHS BY

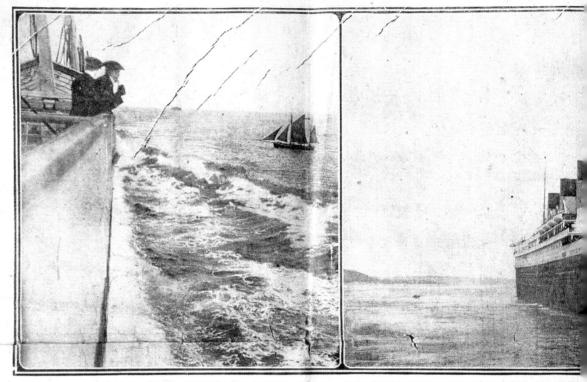

The Titanic dropping the Southampton pilot off Portsmouth last Wednesday. He was taken ashore by an Isle of Wight boat. In the distance are the Channel torts. This photograph was taken from the upper promeaned deck.

he last photograph of the lost liner, the Titanic leaving Queenstown Harbou

BUSINESS HELD UP BY THE ECLIPSE OF THE SUN.

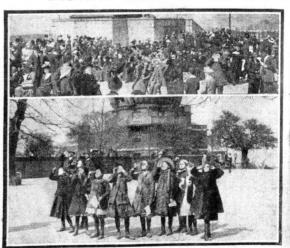

Everybody paused in their daily ion yearcins, and the compact of the sun. Leisured folk took it quite comfortably by accepting the in intain to make their observations from Seltridge's roof garden. Below is a photograph of condren looking at the eclipse under the shadow of the dome at Greenwich Observation?

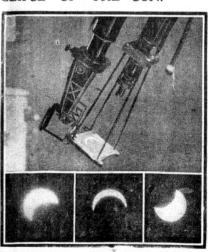

Taking a photograph at the West Kensington Observatory at the moment of the greatest obscuration.

Photographs of the eclipse at 11.40 noon and 12.50.

photograph

APRIL 18, 1912.

NGER WHO LEFT THE DOOMED TITANIC AT QUEENSTOWN.

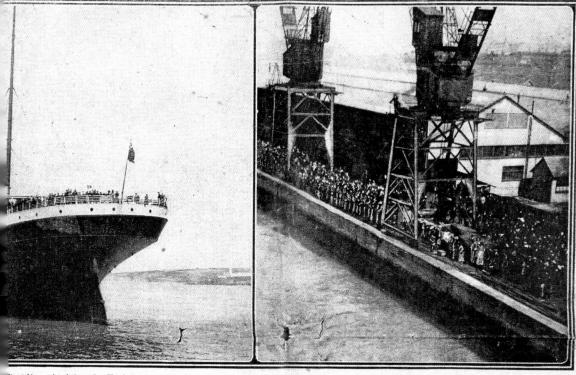

fter taking on board the mails. The decks are crowded with passengers waving a

Good-bye to Southampton.

A photograph taken from the top deck as the Titanic cast off and commenced her first and last voyage.

EVERYBODY SUN-GAZING AT NOON YESTERDAY.

ended at 1.31 p.m., crliament.

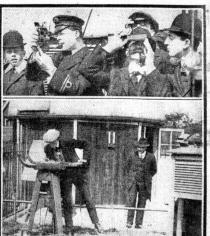

The old way and the new—a navai officer using a sextant alongside a man gazing through smoked glass. Below is Mr. Hawke examining the radiator at the Scientific Society's Observatory at Hampstead Heath.

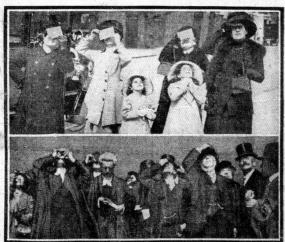

A motor-car party provided with glasses on Hampstead Heath.

An adjournment at the Law Courts whilst judge jury and counsel go outside to view the eclipse.

Doily Sketch Photograph.

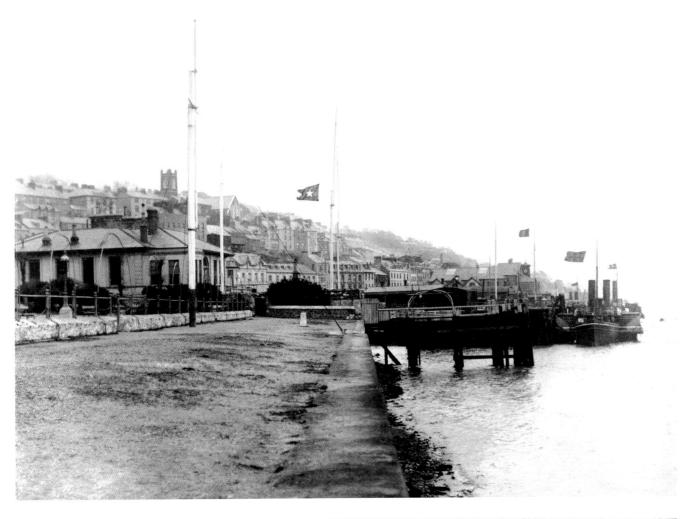

Queenstown in mourning, with flags at half-staff, 19 April 1912. The building on the left is the Cunard Office, now Trustee Savings Bank, with the White Star agents, Messrs James Scott & Company, to the rear. The tenders *Ireland* and *America* can be seen moored to the right. The deserted quay tells its own story.

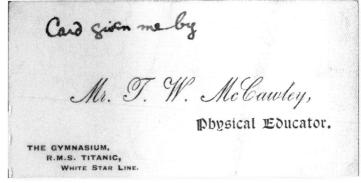

From Browne's *Titanic* Album – see page 41 – a cherished memento given to Frank Browne by Mr McCawley, the liner's physical education officer, who lost his life in the tragedy.

Excerpt of Minutes of Cork Harbour Board

The SS Titanic called at Queenstown on Thursday 11 April 1912 and embarked Mails and Passengers for New York on her Maiden Voyage.

Passengers and Crew, 2,358.

At a meeting of the Board held on Wednesday, 17 April 1912, Mr C. J. Engledew in very feeling language referred to the very appalling disaster to the White Star Steamship *Titanic*, which Vessel struck an Iceberg, off the banks of Newfoundland, and was lost in latitude 41-46 North and Longitude 50-14 West on the morning of the 15th instant and which calamity swamped in death over 1,600 persons.

The catastrophe he described as the most terrible in the history of the Sea, and moved the following resolution which he suggested should be transmitted to Messrs Ismay Imrie & Co. through Mr J. W. Scott (Queenstown) Agent, White Star Line:

That we the Members of the Cork Harbour Board desire to convey to the friends and relatives of those who have lost their lives in the *Titanic* disaster, and also to Messrs Ismay Imrie & Co. our deepest and most sincere sympathy with them in the dreadful loss that has overtaken them.

Mr Haughton also in sympathetic language seconded the motion which was supported by several Members and put by the Chairman and unanimously agreed to.

Excessive Speed What the Californian might have done.

Lord Mersey yesterday delivered the judgement of the Court that inquired into the loss of the *Titanic*

Many ladies went to the Scottish Hall, Buckingham Gate, to hear the judgement read, among them an elderly woman in mourning, her hat trimmed with ostrich feathers.

Lord Mersey found that the disaster was due to collision with an iceberg brought about by the excessive speed at which the ship was being navigated. Captain Smith made a very grievous mistake in not reducing speed at night when he reached the region where ice might be expected; but in view of the fact that it had not been the practice of liners to reduce speed so long as the weather was clear he was not guilty of negligence and it was impossible to fix him with blame.

It was to be hoped that the last had been heard of the practice of going at full speed at night in an ice region – a practice due probably to competition and the desire of the public for quick passages.

It was irregular for Captain Smith to give Mr Ismay the *Baltic's* ice message and improper for Mr Ismay to retain it, but that incident had no influence on navigation.

Lord Mersey did not believe that the presence of Mr Ismay on board induced Captain Smith to neglect precautions that he would otherwise have taken; Captain Smith was not trying to please anybody, but was exercising his own discretion.

SIR COSMO DUFF-GORDON

The ladies took a keen interest in that part of the judgement dealing with Sir Cosmo Duff-Gordon. It will be remembered that the calling of Sir Cosmo and Lady Duff-Gordon as witnesses attracted large numbers of women to the inquiry. Lord Mersey found that the gross charge made against Sir Cosmo of having bribed the crew of No.1 boat to row away from the drowning people was unfounded.

Lord Mersey did not agree that Mr. Bruce Ismay's position as managing director of the company imposed on him a moral duty to wait on board until the ship sank. If he had not jumped into the boat another life would have been lost.

As for the *Californian*, the Court's finding was that when she first saw the rockets the *Californian* could have pushed through the ice to the open water without any serious risk and so have come to the rescue of the *Titanic*. Had she done so, she might have saved many, if not all of the lives that were lost.

A good and proper look-out for ice was not kept. An extra look-out should have been placed on the stem-head and a sharp look-out from both sides of the bridge.

Frank Browne followed the Titanic investigation avidly in the newspapers and kept many press cuttings such as this. From his correspondence we know that he was inclined to agree with the investigators' findings, in general, though he disagreed with the suggestion - and could prove this from his photographs - that Captain Smith was aiming for record time. As for the Californian, we know, since 1985 of course, that she was nearly fourteen miles further away than the investigators believed, and on the other side of an ice-field. Her much-maligned captain, Stanley Lord, could have saved nobody.

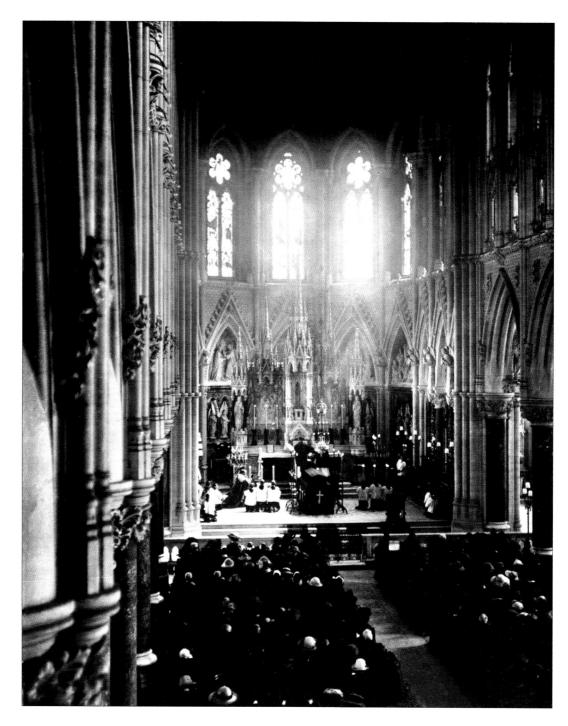

Requiem Mass in St Colman's Cathedral, Queenstown, on 22 April 1912. Browne's uncle, Bishop Robert Browne, presided.

Frank Browne collated all the letters he received from fellow-passengers on the Titanic, some of whom wrote frequently. I have selected a few, reproduced here, that convey their content.

18 April 1912

Dear Father Browne,

We only heard yesterday of the awful news of the shipwreck of the Titanic. It is all most terribly sad and I can hardly realise that that enormous mass of ironwork is at the bottom of the ocean and such a fearful loss of life. I wonder if any of your friends escaped?

... Now your photos will have a sad interest in them...

Thanks for all your kindness to us on board the ill-fated Titanic.

Yours sincerely,

G. T. Noel,

Finisterre, France.

20 April 1912

Dear Friend,

We feel we must write to you as we were passengers on the poor Titanic together. What an awful disaster it is. We have wondered so much whether the gentleman friend of the lady who came ashore with us at Queenstown is saved, as we do not know his name. If you know it, will you kindly let us have it...

With kind regards, Yours sincerely, (Mrs) L. Odell, Stile House, Lime Regis, Dorset.

The most voluminous correspondence was with the writer, R. W. May, brother of Mrs Odell, and therefore an uncle of the Jack Odell whose picture we have seen on page 66. His first letter was oddly addressed, as shown above.

20 May 1912

My dear Father Browne,

I do not know how to thank you sufficiently for your great kindness in sending such a splendid lot of photos which are of great interest – rather melancholy interest.

If you are ever in this part of the country, do let us know, as we should all be so pleased to see you here.

Yours sincerely, G. T. Noel, Temple Guiting House, Winchcombe, Glos.

20 April 1912

My dear Sir,

I hope this queerly addressed letter will reach you. You will doubtless remember us all sitting together on the ill-fated Titanic so I take the liberty 1st of asking you if you would favour me with some copies of your excellent photos some of which I've seen printed, one of which has my little nephew. 2ndly, do you happen to know the names of the lady and gentleman

at your left at the table and whether they are among the saved? Yours faithfully.

R. W. May, Gresham Road, Brixton, S. W.

8 May 1912

My dear Sir,

Accept my best thanks for your very kind letter. I shall look forward to my copies of the photos you can send me. When I get some of those we took, I'll be prepared to let you have a few. Perhaps my sister, Mrs. Odell, has already promised them to you...

I return the 'W. S. Co' lecture to you. The lady's name was, I believe, Mrs Noden. The gentleman's name I did not have at all, so cannot say if among the saved or not. I was so glad to hear you had a prize for your pictures.*

Yours truly, R. W. May

*This is the only reference I could find for Frank Browne having won a prize for his *Titanic* photographs.

4 May 1912

Dear Mr Browne.

Very many thanks ... Have you ever heard of this little book and will you accept it with my thanks for what you so kindly did for me.

Yours sincerely, R. W. May.

19 June 1912

Dear Mr Browne,

Many thanks for The Belvederian containing your excellent article, I've taken the liberty of writing to Dublin and asking for three copies to be sent to me ... The allusions to Mr. McElroy and Mr. Nicholson are aptly appropriate and just enough.

I suppose you are following the Enquiry. In places I think a little levity is shown. A pity, but time I suppose as usual tends to assuage the grief of loss. But a moment's reflection, on my part, brings everything so vividly to mind. One cannot think of any part of the occurrence light-heartedly.

Another book is approaching completion. I hope to send you a copy shortly.

Sincerely yours, R. W. May.

1 January 1913

Dear Mr Browne,

Accept my best wishes to you for 1913, though a little late. I never wrote and thanked you for the last photo. I think it's indeed quite a curio and I like it even better than the one with poor Smith looking down from the bridge. You said you had the negative...

Sincerely yours, R. W. May.

Jagos 1, Gresham Road.

erheit 1, Gresham Road,
Brixton, S.M.
20/4/,2

Thope this querrey addressed letter will reach you, You will doubten ill-faled "Titamic, on I lake the library In of asking you if you would favor me with a few copies of your exallent photos some garace I've den princip, one of which has my livre replace in . I would prefu you to make a charge if you will, Mores to li augment the find being vaised for the poor relacions. where friend Itype may be well pariol of for. More 2 may. do you happer when the name of the Lacy & Lureme as your Cop at later. 8. distre among the rowed! I would like lo juo ma a line Twas a Shod to us all when we received the news from Landon al 9.30 am. al-Toughal. Cows was sem or I Twist the firs- news of the disasties in Treated. The Acus privace Monga is was con Anead We wild fixe belluas of come ocarces creating. I then you

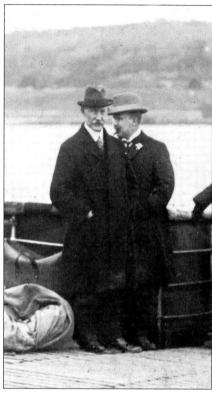

R. W. May standing behind his brother, Stanley May.

Chapter 9

Browne's *Titanic* Photographs in the Public Imagination

Even in 1912 Frank Browne started to give public lectures on the *Titanic*, illustrated with lantern slides. To supplement his own *Titanic* photographs he acquired materials that dealt with the disaster itself such as radio messages and illustrations from a variety of sources of the actual sinking.

Obviously, the White Star Line heard about the Browne lectures because in March 1913 the letter reproduced on the facing page reached Browne in Dublin. 'We shall be glad', it announced, 'to obtain photographs of the illustrations to which you allude in the "Olympic" booklet,' and then continues with a truly breathtaking request, 'but shall appreciate it if in any lectures you deliver, you will abstain from any reference to the "Titanic", as you will understand that we do not wish the memory of this calamity should be perpetuated.'

As everyone knows, the reason so many lives were lost at the time of the disaster was that the *Titanic* did not have enough lifeboats. As a result of the investigation, ships were required to carry sufficient lifeboat capacity for everyone on board. The photographs on pages 134 and 135 show how this was put into practice. Interestingly, some – such as director James Cameron – have suggested that given how quickly the *Titanic* was sinking, the crew would not have been able to launch more lifeboats than they did.

The *Daily Express* of London commemorated the twentieth anniversary of the loss of the *Titanic* on the 15 April 1932, and it used Browne's photographs to illustrate the text. Its front page is reproduced here.

The *Weekly Illustrated* of London commemorated the twenty-fifth anniversary of the tragedy with a feature about a wonderful but untrue tale of 'The Most Romantic Picture Ever Taken' (p. 118), also using Browne's photographs. The 'most romantic picture ever taken' was of a young boy spinning his top on the Saloon Deck. Browne did not know that this picture was in fact of the Spedden boy (p. 74). He was convinced the boy was one of the famous '*Titanic* Orphans', two boys who had been rescued from the *Titanic* without a parent or guardian. These boys, later identified as Michel and Edmond Navratil, were taken onboard the *Titanic* by their father – who was fleeing a bankruptcy notice – without their mother's knowledge. The body of the father was later brought to Halifax, Nova Scotia, and buried in the Jewish cemetery under the name he had assumed. 'Hoffman'.

Michel and Edmond Navratil were rescued by the *Carpathia* from a collapsible lifeboat D, the last lifeboat successfully launched from the *Titanic*, and were eventually re-united with their mother. Edmond became an architect and died in 1953. Michel became a professor of philosophy at the University of Montpellier and died in 2001.

COCKSPUR STREET, SW.
"Oceanic House".
38, LEADENHALL STREET, E.C.
LONDON.

CANUTE ROAD, SOUTHAMPTON.

84. STATE ST. BOSTON.

53. DALHOUSIE ST OUEBEC.

21, PIAZZA DELLA BORSA, NAPLES.

VIA ALLA NUNZIATA,Nº 18 GENOA.

PARIS AGENT: NICHOLAS MARYIN. 9, RUE SCRIBE

POLEORANDE SOLUVERPOOL
ADDRESS "OCEANIC, UVERPOOL"

McC.

(PLEASE ADDRESS ANY REPLY TO THE MANAGERS & MENTION THE DEPARTMENT.

LIVERPOOL, March 4th, 1913.

The Rev: F.M.Brown, S.J.
Hilltown Park,
DUBLIN.

WHITE STAR LINE SERVICES.

SOUTHAMPTON-CHERBOURG-NEW YORK.
ROYAL & UNITED STATES MAIL STEAMERS.
VIA QUEENSTOWN (WESTBOUND)-PLYMOUTH (EASTBOUND)

LIVERPOOL - NEW YORK. VIA QUEENSTOWN.

LIVERPOOL-NEW YORK.
(FREIGHT.)

LIVERPOOL - BOSTON.

LIVERPOOL-QUEBEC-MONTREAL. LIVERPOOL-HALIFAX-PORTLAND. Dear Sir,

LIVERPOOL-AUSTRALIA.

LIVERPOOL-AUSTRALIA. (FREIGHT.)

LIVERPOOL-NEW ZEALAND. (FREIGHT.)

LONDON - NEW ZEALAND. VIA SOUTH AFRICA.

New York-Mediterranean. Via Azores.

BOSTON - MEDITERRANEAN.
VIA AZORES.

THROUGH BOOKINGS TO ALL PARTS OF THE WORLD. We duly received your favour of the 1st instant, all contents of which have our careful attention.

We shall be glad to obtain photographs of the illustrations to which you allude in the "Olympic" booklet, but shall appreciate it if in any lectures you deliver, you will abstein from the reference to the loss of the "Titanio", as you will ensity understand that we do not wish that the memory of this salamity should be perpetuated.

Yours faithfully,

For WHITE STAR LINE .

Real

White Star letter sent to Frank Browne on 4 March 1913.

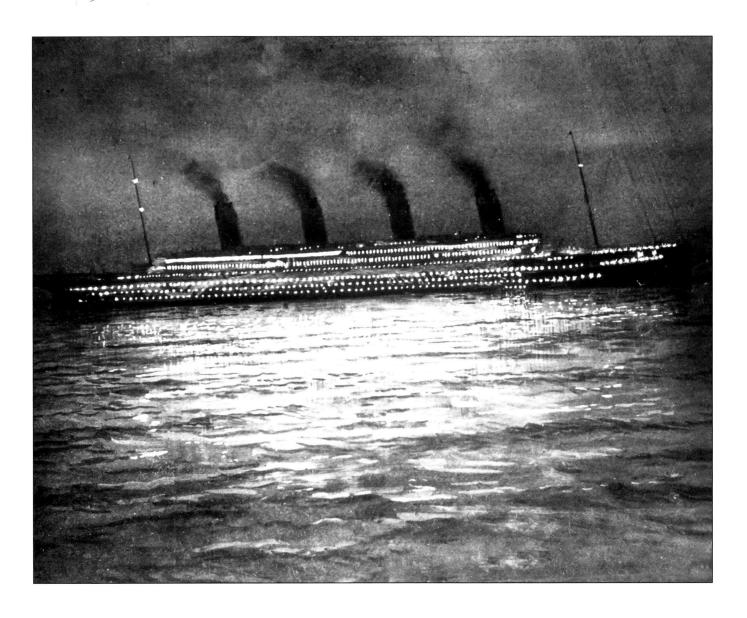

An illustration of the *Titanic* at night, anchored off Cherbourg. This was used by Frank Browne for his public lectures and was taken from the supplement to *The Sphere*, London, 20 April 1912.

DIAGRAM III.-HOW THE "TITANIC" GRADUALLY SANK BOW FIRST WITH HER LIGHTS BLAZING TO LAST.

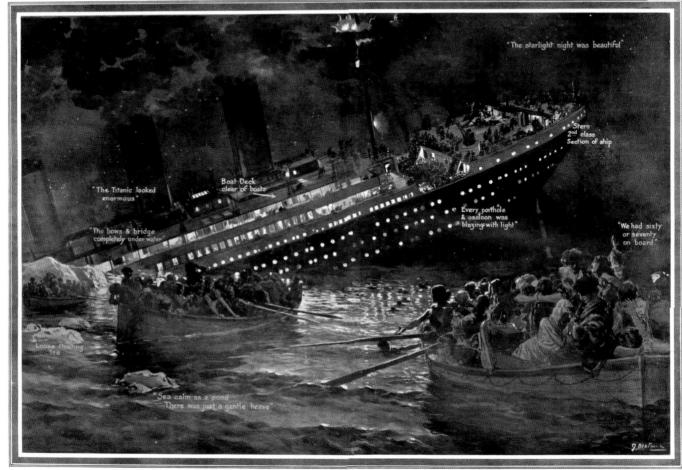

RAGRAM III. "THE "TITANIC" LOKED ENORMOUS-EVERY PORTHOLE AND SALOON WAS BLAZING WITH LIGHT

magine was bountful, but as there was no more a was not very lab. The rea was not seed play. There was not any partial. There was not any partial the seed of the best objected as out diseas on the most. It was ablest major recognition to the third control, the seed and major provides the theory control on the second of the observed ones, botherd more more. Here long not the provides the control of the second of the sec

were c uso for the common of classroople in the lower, where the water was to size up to the fewer twent probables. At where two-clocks we character has setting very reguly with the low and the budge completely assists waves.

"The should stood variety to see our too for foreign to work were verified by quarter, A die slide to the sights as the raison and the solvent which had not followed for a money over we let it out our facilities were not the foreign at the sight as a consist of the sight and the raison of the sight and the mathems fourth down through the result with a granting rather that rould have been have for mire. It was the worders require that the size has been haust in the motifies of the line may be an extra the size of the the pignitir releaf is which we set out from Nephweights. They there left us our case more appealing access that homes being even hants the cover of patients of our holes from excepting a few has water through as held not it in high left of the product of the product of the covered of t

The *Titanic* sinks. Artist's impression from the same issue of *The Sphere*. This was turned into a lantern-slide and used (with permission) by Frank Browne in his public lectures.

The front page of London's *Daily Express*, 15 April 1932.

TWENTY-FIVE YEARS AGO

A STORY

that has

NEVER been told

Twenty-fice years ago next Wednesday, April 14, the biggest thip in the world, the Cunarder ''Titanic,'' went down with 1,400 out of her 2,201 passengers and crew. The picture on the left, showing the children's playground on the saloon dech, was taken by the Rev. F. M. Browne, S.J., who sailed from Cherbourg on Wednesday, April 10, leaving the ship at Queenstown three days before she went to her doorn. The stronge story of this picture—a story stronge story of this picture—a

DROWNED

The tragic story of a father who kidnapped his own children, and lost his life while taking them to America in the "Titanic," is told for the first time

In a letter from St. Mary's, Em Portarington, concerning the pictual (above), Father Browne writes:

"A couple of months after the disast instance of months after the disast restance of months after the disast restance of the standard provent to be the standard pr

The mother, with two children—this boy and a girl one year younger—had been living on the Riviera. The father had planned to kidnap the children and had taken their nurse into his confidence and arranged a meeting place.

a car in a provincial French town, motored to Nice, met the nurse and the children and then drove to Cherbourg where, under another alias, he sold the car and, under a third alias, embarked

I met the children in the lounge and became very friendly with them. On the following morning I took this snapshot When the liner was going down, the father brought the children to the bot in which Mrs. Benjamin Guggenheim was about to escape. The father and the nurse both went down with the ship know their real name and no one claimed them under their alias.

Mrs. Guggenheim, whose husband had been drowned, was on the point of adopting them when a reproduction of this photograph of mine appeared in a Spanish paper. The mother of the children, who had been vainly attempting to trace them, recognising the father (centre figure) and the boy, went to New York and claimed them.

This is a romance of twenty-five year ago, but it seems to me that as the stor was never published, it is as interestin to-day as it was in 1912."

MORE "TITANIC" PICTURES

FATHER BROWNE'S ALBUM

seenstown Harbour. Tiny figure er at top of after funnel caused nation among woomen and n. Stoher was all right, funnel ring only a huge ventilator.

Right, in the "Titanic's" gy nassum. T. W. McCauley, shi physical-training expert, and eltrician, Mr. Pow, were both lost the disaster.

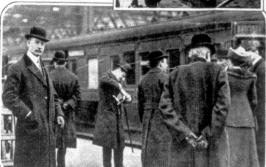

THE ONLY "'TITANIC' SPECIAL"

Taken on platform of Waterloo at departure of first and lass "'Titanic' Special," picture shows Col. J. J. Astor. Jameus American

Years Old

Long Life and Good Health thanks to

SHERLEY'S

The state of the s

up, and I feel sure that this built he foundation of his future health. He was occasionally treated with your Worm medicinest, and I also gare kim your Toma and Condition Pooclers. He was a much travelled dog, having spent several years in Germany and the last few years of his hie he spent in Switzerland. Yours faithfully (Signed) M. W. (Mrs.)

SHERLEY'S 2D. A le

I

On its front cover, the London *Weekly Illustrated* of 10 April 1912, described one of Father Browne's photographs as 'the most romantic picture ever taken'. This referred to the photograph of Douglas Spedden (p. 74). The inside feature, shown here, elaborates.

Browne, in fact, did not know that this photograph showed the Spedden boy. He was definitely of the opinion that the boy spinning his top on the Saloon Deck was one of the famous '*Titanic* Orphans' who were about to be adopted by Mrs Guggenheim when their true identity emerged.

As Father Browne heard it, M. Navratil, a rich man living in the south of France, decided in April 1912 to abscond with his children's governess. Hiring a car under an assumed name, the couple drove to Cherbourg with the man's two sons who were then aged four years and two years respectively. The four sailed on the *Titanic* and, after the collision with the iceberg, the boys were given space in a lifeboat and were eventually rescued by the *Carpathia*. Both the governess and M. Navratil were lost.

The Weekly Illustrated of 1937 quotes Father Browne as saying that the boys' mother saw 'this photograph of mine' in a Spanish newspaper – the picture entitled 'The Children's Playground' – and was able to travel to New York and reclaim her sons.

In 1937, Frank Browne was still under the impression that it was his photograph that the mother had seen. With hindsight we know that it must have been one of the American wire pictures which appeared in that Spanish newspaper. Somebody, confusing the photographs, obviously told the priest that his photograph had worked a wonder: he was not a man to invent such a story.

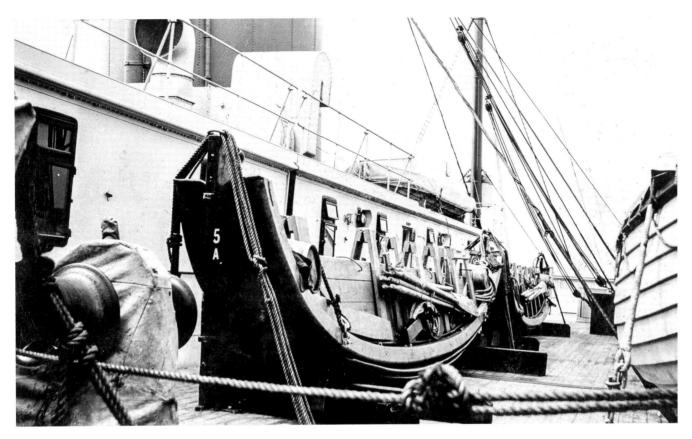

After the *Titanic* disaster, all ships had to carry sufficient lifeboats to save all on board. Here we see 'Berthon' collapsible boats on board the White Star liner *Majestic*.

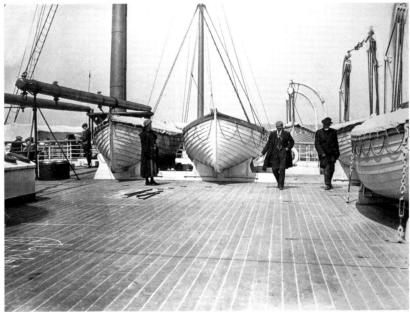

Extra lifeboats were placed on the decks on the White Star liner *Baltic* to implement the new British Board of Trade ruling.

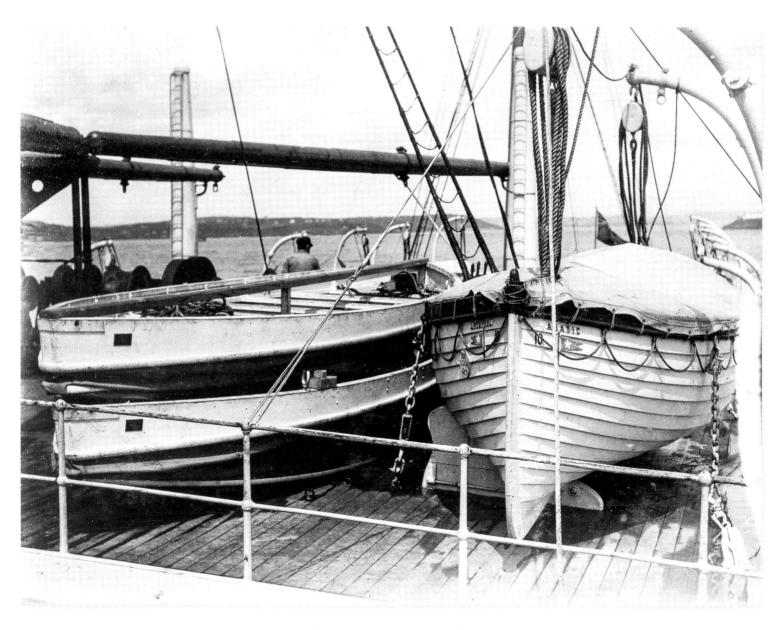

'Henderson' collapsible boats on the White Star liner *Arabic*. Besides the solid gunwales, the keels of these boats are also solid. On being lifted up, they open like a concertina and are then kept in shape by means of struts and bolts.

They could accommodate about twenty people.

No. Words.	Origin. Station.	Time banded in.	· Via.	Remarks	
		HM. / i8			
То	Litamie		1	and the second second	
				The same of the sa	
E10505	bus cq	degle -	m 54		Service of the servic
			7		
	The state of the s				- J-n
			A		
We are	sinking	fast	passing	is in	
We are being x	sinking aut into	fast books	passinge	ns en	
We are being p	sinking out into	- fast books	passinge m 47	is in	
We are being p	sinking out into	- Jast - Soats	m sy	no en	
We are being p	sinking out into	Y	1	t han a	
We are being p	sinking out into		m gy		

Three Russian telegrams acquired by Frank Browne for his illustrated lectures on the *Titanic*.

No.	Words	Origin. Station.	Time handed in.	Via.	Remarks.
То	`.		HM.	,	
,	10				
cq		mgy /			.)
		W	omen and last on by	Chelar	en in
bor	As	annot	mby	much	longer
				95Ward	
			*		

Русское Во	сточно-Аэіатское	Пароходство.
The Russian	East Asiatic S. S. Co.	Radio-Telegram.
19 m	s. s. Burna	Delivered to
No Words. Origin. Station	. Time handed in Via	Remarks.
g. Zitani	i 11.55 Mafril 14-15	Distress Call Ligo Lond
Cgd-sos We ho	to our assistant 41.46 n.	m. G. Y erg sinking
fast come	to our assista	nee !
Workon 1	at 41.49 n.	Jon 50 14 W
→	mgy	
		• -
	A	1. Carnon
	Z.	DWard.

Chapter 10

Grieving the *Titanic*

This final photograph catches well the mood of the poem (facing page) written by Browne shortly after the ship sank. It shows the *Titanic* Memorial in Donegall Square, Belfast, taken by Browne in 1937.

The picture, with its ironic back-drop of the Ocean Accident & Guarantee Company, could not be taken nowadays because the statue was moved to the grounds of City Hall some years ago.

Rode forth to the open sea,
But gone are her gladness, those, opinide,
For the Northern Ocean's depths could hide
Quightier hower than she.

In Memoriam

15 April 1912

A Ship rode forth on the Noonday tide Rode forth to the open sea.

And the high sun shone on the good ship's side.

And all seemed gladness, and hope, and pride

For a gallant sight was she.

For the crew was strong, and the captain brave

And never a fear had they. Never a thought for the turbulent wave, Never a dread of a watery grave, Nor dreams of a fateful day.

So the ship sailed on, and the voices strong Sang sweet on the morning air,

And the glad notes billowed the shore along.

Then drifted and died, till the Sailor's song Was soft as a whispered prayer.

And all seemed gladness, and hope, and pride.

As far as the eye could see,

For where was the foe that could pierce her side.

Or where in the Ocean depths could hide, A mightier power than she?

But far to the North, in the frozen zone Where the Ice King holds his sway, Full many a berg, like a monarch's throne, Or castle that fabled princes own Gleamed white neath the Sun's bright ray. When the challenge came on the whisp'ring

It passed like a fleeting breath, But it roused the King in his Arctic lair. And waked what vengeance was sleeping there.

The vengeance of Doom and Death.

But heedless and gay o'er the sunlit waves The vessel all lightly bore,

Till the distant coast with its rocks and caves

And the land that the Western Ocean laves. Were seen from her decks no more

When Evening came with its waning light, And shrouded the rolling deep. For never a moment she staved her flight, Adown the path of the moonbeams bright, Though Heaven was wrapped in sleep.

Another dawn with its liquid gold Gilded the Eastern sky Lighting the Ship so fair, so bold, That sped its way o'er the Ocean old, Nor recked of danger nigh...

And noonday came, when the burning sun Rifted the realms of snow, And burst the fetters the Ice had spun And shattered the towers that Cold had won, Breaking the great Ice-flow.

Till over the Ocean's heaving swell, Like ghosts in the twilight gloom. The great bergs glided with purpose fell Minding the quest of their Monarch well. The quest of Revenge and Doom.

The deeper night with its slow advance Bids even the winds to cease. No moonbeams bright on the waters dance But all lies still in a starry trance And the Ocean sleeps in peace.

A shuddering gasp o'er the resting deep! A wail from the silent sea! 'Tis heard where the stars their lone watch

'Tis heard in the graves where dead men sleep.

mindful of human glee...

The Springtime dawn with its rosy light Sees naught but the waves' wild flow For under the veil of the moonless night When the sea was still and the stars were bright

The Ice King had slain his foe.

The ship that rode on noonday tide Rode forth to the open sea, But gone are the gladness, the hope and pride.

For the Northern Ocean's depths could

A mightier power than she.

Founder/President Edward S. Kamuda The Titanic Commutator The quarterly magazine of the Titanic Historical Society continuous publication since 1963

> Editor-in-Chief Edward Kamuda Publisher Karen Kamuda Historian Donald Lynch

Reference Ray Lepien Ken Marschall Eric Sauder

Business Staff Anne Gorman Barbara Kamuda The

Titanic Historical Society Collection

The Titanic Museum in Indian Orchard The collection is

The collection is an educational, yet polgnant experience about the Titanic with rare documents next to more familiar pieces — a third-class menu; a wool carpet piece cut from a first-class stateroom on C-Deck; a wood fragment from a lifeboat; boarding passes for the Titanic; postcards and letters mailed from the ill-fated liner; the Marcontgram ice warning from S S Amerika; Titanic lookout Frederick, Titanic lookout Frederick Fleet's rendition of the fatal teeberg; an original Titanic blueprint presented by the builders, Harland and Wolff and recently discovered plans for a 1,000 four-funneled liner. An entire section on Titanic's sisters Olympic and Britannic, photographs, china, posters, newspapers, books, original paintings, sheet music, survivor keepsakes and association pieces are at this unique site.

Marine Museum at Fall River

is here including Mrs. Astor's lifejacket, Lookout Fred Fleet's discharge book and a deckchair retrieved by the Minia. Be sure to see the 28' 1-ton Titanic created for the 1953 20th-Century Fox production, Titanic. The THS was entirely responsible for bringing the film model to the museum in 1985.

THE TITANIC HISTORICAL SOCIETY, INC. PO Box 51053 - Henry's Building, 208 Main Street Indian Orchard, Massachusetts 01151-0053 USA

Mon.-Sat. 10 - 4 closed Sun./holidays Phone (413) 543-4770 Fax (413) 583-3633

12 September, 1996

Father Eddie O'Donnell S.J. Gonzaga College Sandford Road Dublin 6 Ireland

Dear Father Eddie,

We were so pleased to learn the news of your new book, "Father Browne's *Titanic*." If you recall when you kindly addressed our Titanic Historical Society convention in Belfast, No. Ireland at the Europa Hotel last April, you mentioned your plans to publish his photographs and diary.

My wife, Karen, our historian, Don Lynch, and myself are quite excited about this project and it is an honor as officers of the T.H.S. to be of assistance. These images by Father Browne are of immense importance to Titanic historians as well as the general public who have developed an intense curiosity about this great liner owing to increasing publicity. In her brief existence there are very few actual illustrations to chronicle not only the vessel but also those who were aboard Titanic's historic voyage. Few will be able to read this book and not come away without a greater understanding of the people pursuing daily shipboard activities and the beauty and grace of the vessel herself. Some of the passengers and crew in the photos were saved while others shared a different fate. Among the survivors was young Douglas Spedden who can be seen on deck spinning a whip top while others watch his performance. Not so fortunate was Captain Smith, viewed in another photograph, looking down from the bridge at the tenders below at Queenstown. From that height he observed passengers boarding the ship as Father Browne departed and Titanic sailed into her destiny

These remarkable and haunting images are a treasure and we are grateful to Father Browne for leaving a legacy of memories in the photographs of the ship that has become a legend. Likewise, to yourself, our deep appreciation for presenting this document for future generations.

Yours sincerely

Edward S. Kamuda Founder/President

Titanic Historical Society Inc.

INDEX

Adriatic 14
Aherne, David 8, 108
America 14, 20, 29, 79, 80, 81, 85, 101, 109, 122
American Line 8, 59
Andrews, Thomas 52
Arabic 14, 135
Archibald Russell 14
Arnott, F. J. 65
Astor, John Jacob 51
Astor, Nancy 51
Astor, William Waldorf 51

Atacama 14 Atlantic Ocean 11, 77, 106 Ballard, Robert D. 10, 11, 17, 52, 62 Baltic 14, 124, 134 Barker, Thomas 98, 110 Belfast 15, 16, 52, 56, 78, 138 Belvedere College 12, 98, 100, Belvederian, The 8, 65, 98, 100, 127 Bennett's Court 108 Berthon boats 134 Brent (Marconi-man) 93 Bride, Harold 77 Britannic 9, 58 Browne, Brigid 12 Browne, James Snr 12 Browne, James Jnr 48 Browne, Rev. Frank attends memorial service 117, biographical notes 12-14 completes album 32 correspondence with fellow passengers 126-127 description of maiden voyage 100-105

Rrowne, Robert, Bishop of Cloyne 12, 14, 48, 117, 125 Brownrigg, Tom 48, 100, 102 Butt, Major Archibald 66

CB Peterson 14

Caledonia 14 Californian 14, 124 Cardeza, Mrs C D M 72 Carpathia 17, 81, 114, 116, 128, 133, Celtic 14 Cherbourg 16, 18, 48, 51, 69, 72, 76, 104, 106, 130, 133 Chirac, President Jacques 15 Churchill, Winston 14, 105 City of Paris 14, 102 Cobh. See Queenstown Cork 12, 27, 31 Harbour 108-109, 111, 113, 123 Cork Constitution 98, 106 Cork Examiner 98, 108, 110, 111 Cotter, John 108-109 Crosshaven 97 Cunard Line 14, 111, 117, 122

Daily Express 90, 111, 128
Daily Sketch 117, 119
Daunt's Rock 105, 108
Davison, David 15, 84, 99
Deepwater Quay 29
Dublin 12–13, 15, 32, 48, 98–99, 105, 114–117, 126,
Duff-Gordon, Lady Lucy 75, 124

Duff-Gordon, Sir Cosmo 75, 124

Enchantress 14 England 51, 59, 103, 115 Engledew, C J 123 Evening Telegraph 114, 116

Flying Sportsman 14 France 12, 16, 51, 104, 126, 133 Franconia 14 Futrelle, Jacques 70, 104

Galvin, Mrs Mary 23 Gigantic 16, 58 Godalming 115–116 Great Island 108 Guggenheim, Mrs Peggy 133 Guiney, Fr John 32

Haddock, Herbert 115 Halifax 114-115, 128 Harland & Wolff 16, 52, 56-57, 70 Haughton, Benjamin 123 Haverford 14 Hector 60, 62 Henderson Boats 135 Hertzogin Cecilie 14 Holyhead 48

Inman Line 14 Ireland (tug) 14, 25, 28, 29, 112–113, 122 Irish International Salon of Photography 13 Irish Sea 16, 106 Irish Times 114–115 Isle of Wight 68, 103–104 Ismay, J. Bruce 58, 123–124

Joyce, James 105

Imperator 111

Inflexible 14

Kodak Magazine 13 Kronprinzessin Cecilie 111

Laconia 14 Land's End 69 London 16, 18, 32, 48, 50, 90, 116–117, 119, 128, 130, 132–133 London and Southwestern Railway 61 Lord, Captain Stanley 124 Lusitania 14, 111 Lynch, Don 56

McCawley, T. W. 11, 70, 122 McElroy, Herbert 100, 105, 126 McLean, John 79, 80 McVeigh, Captain 112 Majestic 59, 102, 134 Marconi-men 78, 93, 115, 116 Marschall, Ken 56 Mauretania 14, 111 May, R. W. 50, 113, 126–127 May, Stanley 50, 113 Megantic 14 Mercator 14 Mersey, Lord John 124 Milltown Park 48 Minahan, Daisy 109 Minahan, Dr & Mrs W. 109

Navratil, Michel & Edmond 128 Neptune 60, 62 New York 16–18, 74, 98, 99, 111, 114–115, 123, 133 New York 62–63, 64–65, 102–104, 111 Nicholson, M. Arthur 126 No Man's Land Fort 68 Noel, G. T. 126

Oceanic 14, 64–65, 102 Odell Family 9, 110, 112, 126 Odell, Jack 66, 112, 126 Olympic 14, 16, 52, 54, 56, 58, 66, 72, 84, 92, 94–97, 108, 111, 115, 128

Parisian 114
Parr, William 70
Philadelphia 14, 59, 102
Phillips, Jack 77–78, 116
Port Said 77
Portsmouth 67–68, 103

Queenstown (Cobh) 9, 11–12, 14, 16, 18–19, 21, 23, 48, 50, 67, 69, 76, 79, 81–82, 95, 98, 105, 108, 109–110, 115–117, 122–123, 125–126,

Roche's Point 81, 108–109 Ryde 103

Saint Louis 59 Scott, J W & Co. 110, 115, 122–123 Smith, Captain Edward 16–17, 67, 80, 84, 99, 108–109, 124, 139 Solent 67–68 Southampton 16, 18, 32, 48, 61, 63, 65, 70, 75, 84, 98, 100, 103 Spedden, Frederick 74 Spedden, Robert Douglas 74, 128, 133 Sphere The 130–131 Spithead 68, 103–104 St Colman's Cathedral, Queenstown (Cobh) 14, 19, 117, 125

Taft, President William H 66 Tagus 67, 103 Test, River 60 Titanic at Southampton 56-65 collision with iceberg 114-115, 123-124 construction 16 dimensions 16 discovery of wreck 11, 17, 52, lifeboats 11, 16, 60, 68, 70, 72, 75, 80-81, 114-115, 128, 133, maiden voyage to Cherbourg and Queenstown 68-69, 100-107 memorial Belfast 138 plan of ship 52-55, 88-89 safety features 108-111 voyage towards New York 111

Virginian 114–115 Vulcan 65

Waterloo Station 18, 32, 48, 50 Weekly Illustrated 128, 133 White Star line 16, 24, 48, 58–59, 70 123, 128, 134–135 White Star Orchestra 105–106 White Star Wharf, Queenstown 19 World War I 13, 15, 51, 68, 105 World War II 68

INDEX OF PHOTOGRAPHS

America 20, 29, 85 Arabic, 135 Astor, William Waldorf 51

lectures on Titanic 128

press cuttings 118-121

voyage 48

writes poem 139

receives news of disaster 116

receives ticket for maiden

Browne, Rev. William 95, 109

Ballard, Robert D. 10 Baltic, 134 Bride, Harold 78 Browne, Frank 4 Butt, Archibald 66

St Colman's Cathedral 125

Futrelle, Jacques 70 Hector 60, 62 Ireland 25, 28, 29

Majestic 59, 134 May, R. W. 113 May, Stanley 113 McCawley, T. W. 71 McVeigh, Captain 112

Neptune 60, 62 New York 63

Odell family 112 Odell, Jack 66, 112 Olympic 56, 97 Bridge 94 Grand Staircase 96 Marconi Room 93 Reading and Writing Room 92 Swimming-bath 95

Parr, William 71 Philadelphia 59 Phillips, Jack 77

Queenstown 19, 24, 25, 27, 28, 30, 31, 122

Roche's Point 109 Saint Louis 59 Southampton Wharf 61 Spedden, Frederic 74 Spedden, Robert Douglas 74 Smith, Captain Edward 99

Tagus 67
Titanic 9, 57, 58, 65, 79, 81, 83, 85, 101, 130, 131
A-deck 66–67, 72, 75, 76
Boat deck 111
Browne's bedroom 86–87
Dining Room 90
Gymnasium 70–71
Lifeboat 68, 70, 75, 80–81, 99
Marconi Room 78
Menu 90

Memorial 138 Plan 53–55, 88–89 Reading and Writing Room 91 Special 50 Starboard anchor 82

Vulcan 65

Waterloo Station 50 White Star Letter 49, 129

	•					

-							
*							